THE SECRET
LIFE OF
THE PENCIL

For Louise & Lilac

AH

For Nina, Vivienne & Dashiell, always
For Xul

MT

THE SECRET
LIFE OF
THE PENCIL

GREAT CREATIVES
AND THEIR PENCILS

ALEX HAMMOND & MIKE TINNEY

Laurence King Publishing

CONTENTS

THE PENCILS

FOREWORD

THE PENCIL

William Boyd

One day, early in the twentieth century, in pre-revolutionary Russia, a little boy lay ill in bed in St Petersburg. He was called Vladimir Nabokov, and he was destined to become a legendary novelist, but at that time was just a sickly child needing care and consolation. Accordingly, his mother went to Treumann's – a famous department store in St Petersburg – and returned with an enormous present. Little Vladimir unwrapped it to discover that the gift was 'a giant polygonal Faber pencil, four feet long and correspondingly thick'. It was part of a promotional window-dressing display and Mrs Nabokov had – presciently – assumed her son might have been coveting it. He had been. Later he drilled a hole halfway up the pencil to see if the graphite continued for the full length – it did. It was a real pencil. The giant pencil from Treumann's window could have been used to write – by a giant.

This Nabokovian anecdote frequently comes to mind whenever I contemplate my own relationship with the pencil, this humble writing implement. A giant four-foot pencil delivered to a future writer … It seems almost too neat, too aptly significant, but trust the teller not the tale, in this instance. Furthermore, as I began to investigate the origins of the pencil, it was something of a revelation to discover that it was invented in England, in the sixteenth century, in Cumbria, where an incredibly rare supply of pure solid graphite was discovered

underground. Graphite sticks from this mine, wrapped in paper or sheepskin, formed the first pencils. Shortly afterwards the wood casing was added and – effectively – the pencil we use today was born. And now 14 billion pencils are manufactured annually around the world.

It's amazing how the pencil continues to flourish as a drawing or writing implement. For artists it is a machine of unrivalled subtlety with almost two-dozen grades of hardness to softness. For writers it presents more of a challenge: the point has to be sharpened regularly (that takes time, requires precision); it can easily break and you have to start again. For notes and jottings it is ideal but for the long haul of an article, or a story, or a novel, it's perhaps second choice to a pen. However, there is always the mechanical pencil.

The mechanical pencil also has a long history but, essentially, it is a nineteenth-century gadget – the invention of the push-button clutch allowing the feed of the 'ever-pointed' pencil, or propelling pencil as it is sometimes known.

And here is where I intersect with pencil history – or the pencilverse, as aficionados term it. I've always liked writing with pencils, and indeed had a lifelong search for the perfect writing implement. I found it, a couple of decades ago, in a Faber-Castell mechanical pencil [this is the pink pencil you can see on page 55], the latest of many I've owned. The manuscripts of the first ten of my

novels were written in pencil. I stopped using a mechanical pencil out of a vague fear that the graphite would fade over time and since then have resorted to pen (I always write my first drafts in longhand). But the fear – I now realize – is irrational. Pencil writing endures – perhaps as long as ink. Ink can fade as well, after all. I think it's because pencil writing can be so effortlessly erased that one feels it's somehow temporary. But, in a way, the potential of erasure is part of the urge, part of the allure, to write in pencil – the prospect of your words' easy disappearance makes them somehow all the more precious. An inked word has to be crossed out – messy.

By now, we are beginning to move from solid pragmatism to something more philosophical and pretentious. The fundamental nature of the pencil is that it is a brilliant invention and will always be with us. The pencil is like the wheel, the button, the comb, the wheelbarrow, the umbrella, the book, the fork, the needle, the compass, the map, the zip – and so forth. Products of humankind's ingenuity that – whatever the mind-boggling technological advances we continue to make – remain irreplaceably super-efficient and thereby unimprovable on their terms.

I look at my desk as I write this introduction (on a computer). Squarely in front of me is a mechanical pencil (a Pilot Shaker). To one side,

in the old mug that contains my writing implements, are two other mechanical pencils and three traditional pencils – along with two dipping-pens, I should add (I'm a bit low-tech, I admit). In a cupboard three feet away are several tin pencil boxes containing an array of graphite pencils and coloured pencils (for drawing, not writing). I reach instinctively for a pencil when I want to scrawl a note – or doodle. And I'm constantly buying new mechanical pencils out of a perverse desire to see if I can better my old Faber-Castell. Why? I'm quite happy with the pens I use (fine-point markers, in the main), so why do I keep resorting to pencils?

My latest theory is that it is because *only with a pencil* can you really establish what your true handwriting is like. I notice that as I move from pencil to biro to felt-tip to fountain pen to rollerball to fine-point marker, my handwriting changes in various small ways, usually for the worse. I'm aware of this – the hand to implement to mark-on-paper interface is affected by the choice of writing apparatus you use. But – intriguingly – I don't think about this when I use a pencil. I now feel that this is probably because the very first things you write with as a child are pencils (back to Nabokov, again). Your sense of yourself, as reflected in your handwriting – which is unique, after all – is best defined by a pencil. Your pencil – in a very real way – is you.

Gerald Scarfe
Cartoonist

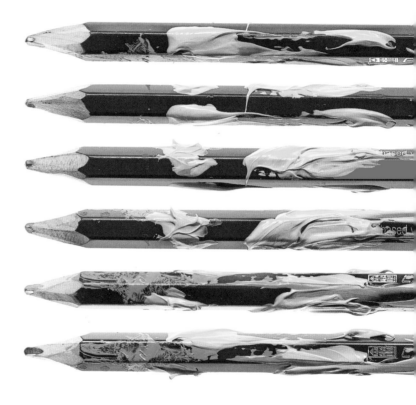

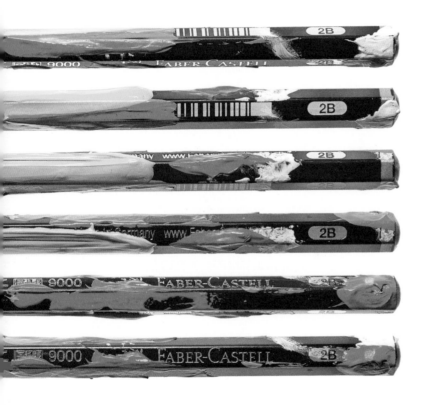

Sir Anish Kapoor
Sculptor

Philippe Starck >
Designer

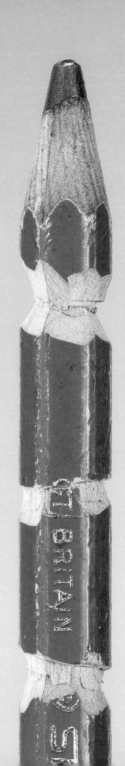

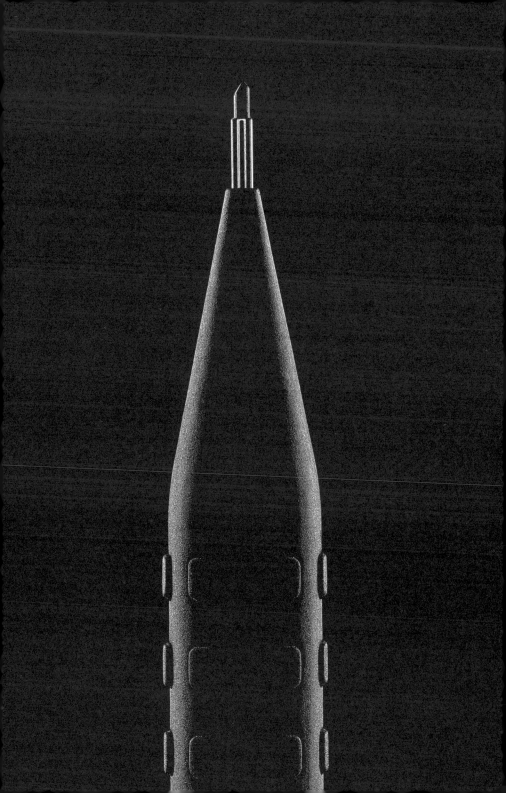

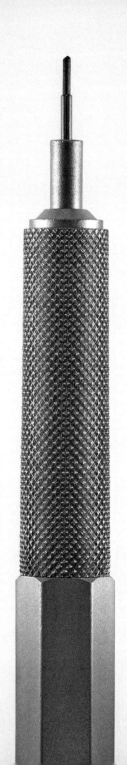

Sir James Dyson
Inventor

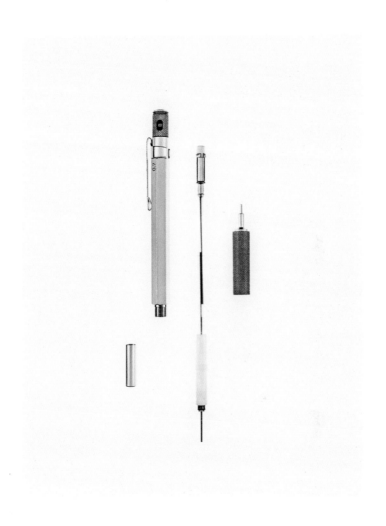

"DRAWING IS STILL THE BEST WAY TO COMMUNICATE IDEAS QUICKLY."

SIR JAMES DYSON

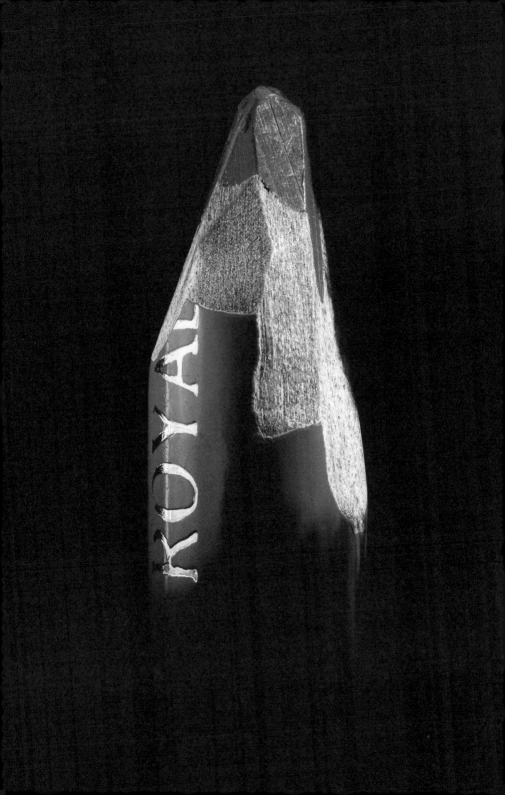

< **David Bailey**
Photographer
Interview, page 110

Pam Hogg
Fashion designer

Edward Barber
Designer

Asif Khan
Architect

Celia Birtwell
Textile designer

Makoto Tanijiri >
Architect

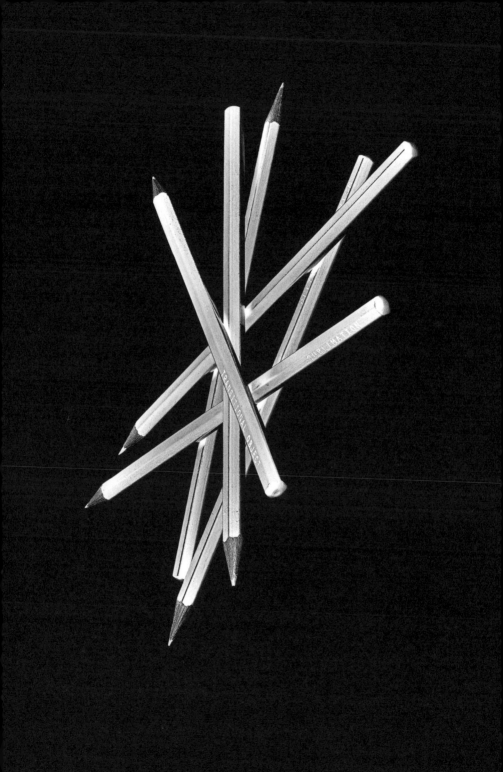

Sargy Mann

Artist

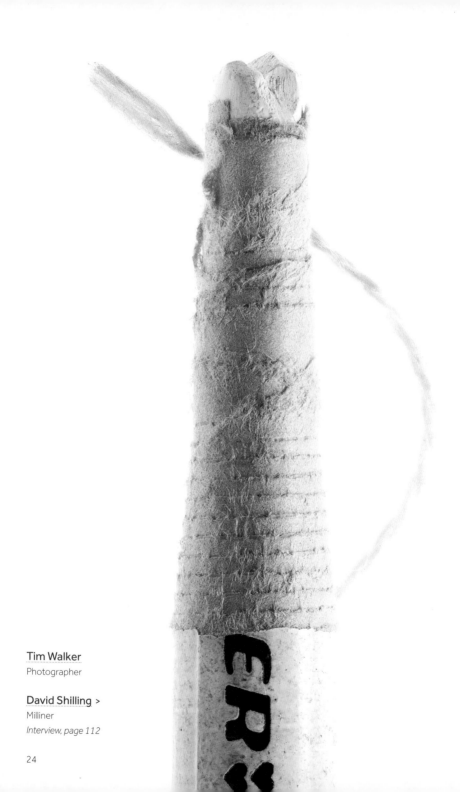

Tim Walker
Photographer

David Shilling >
Milliner
Interview, page 112

"I LOVE DRAWING WITH A PENCIL BECAUSE IT'S PART OF ME ... IT'S INSTANT, ORGANIC AND DIRECT."

MICHÈLE BURKE

Michèle Burke
Makeup designer
Interview, page 114

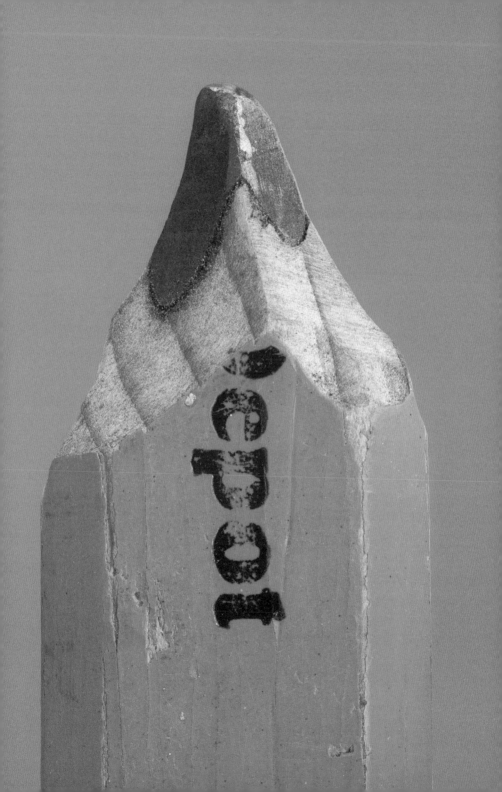

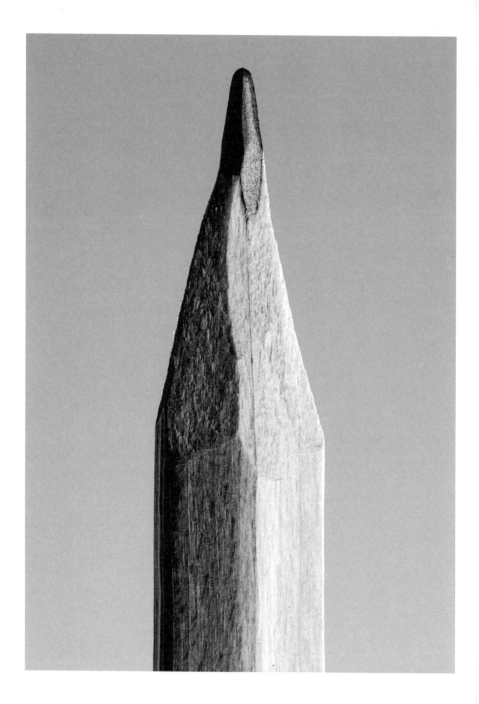

Stephen Fry
Actor and writer

Dame Zandra Rhodes >
Fashion designer

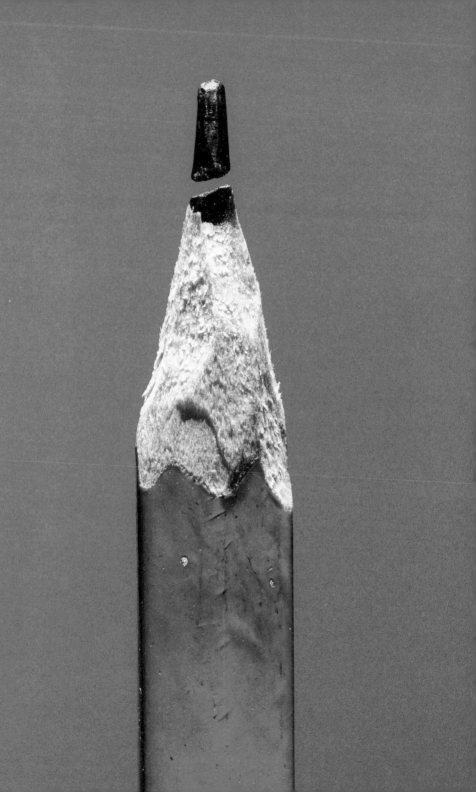

"THERE IS SOMETHING ABOUT THE ACT OF DRAWING THAT BYPASSES MUNDANE CONSCIOUSNESS AND REACHES STRAIGHT TO THE BRAIN."

TRACEY EMIN

Tracey Emin
Artist

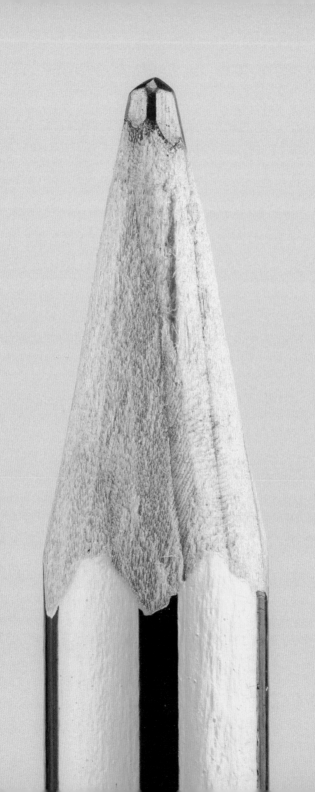

< Dave Eggers
Author

Henry Holland
Fashion designer

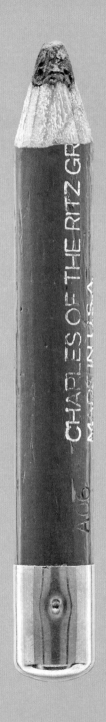

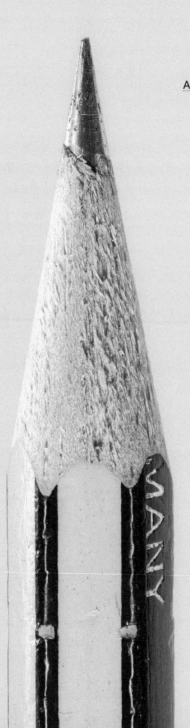

< Sir Peter Scott
Conservationist

Alexander McCall Smith
Author

"IT IS THE VERY MUTABILITY OF THE PENCIL MARK THAT ENABLES ONE TO KEEP THINKING IN PROCESS."

PETER SAVILLE

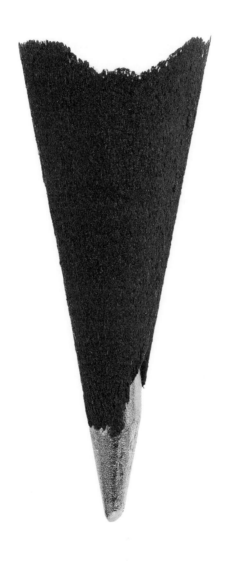

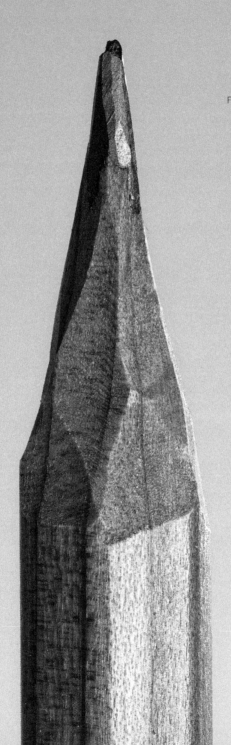

< **Dick Walter**
Composer

Mike Leigh
Film and theatre director

41

Mark Dytham and Astrid Klein
Architects

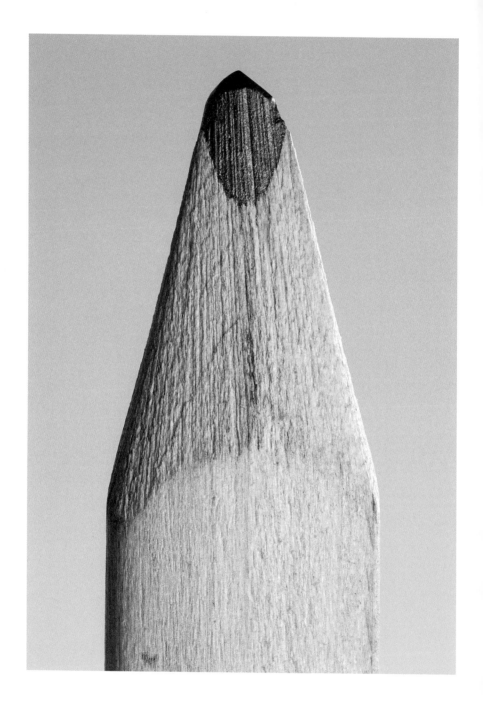

Sir Nicholas Grimshaw
Architect

Glenn Brown >
Artist

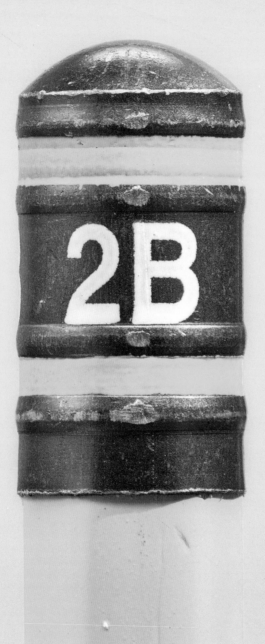

< **Bill Woodrow**
Sculptor

Will Alsop
Architect

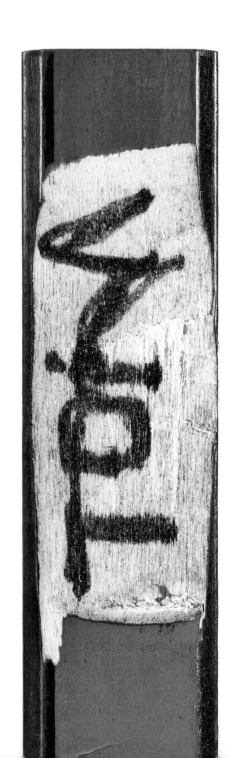

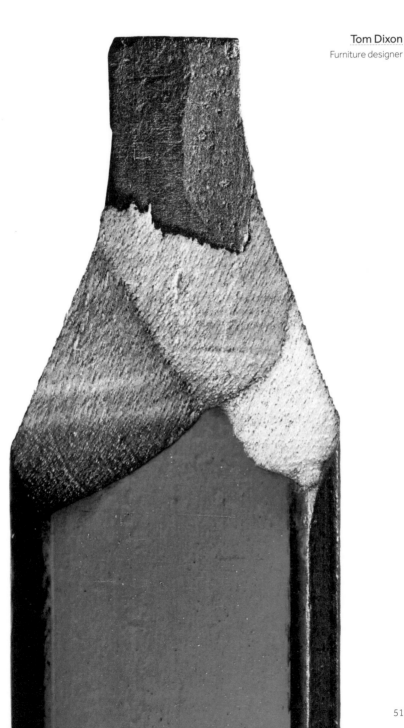

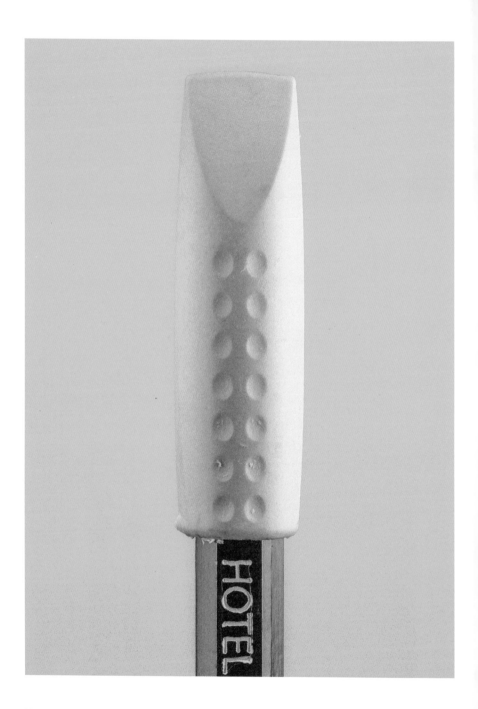

Nigo
Fashion designer

Matthew James Ashton >
Toy designer
Interview, page 118

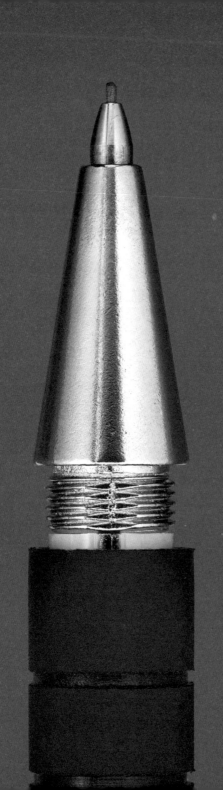

"THE 'LINE' A PENCIL MAKES CAN BE SO MANY THINGS AND GRADATIONS OF SHADING CAN BE ASTONISHINGLY SUBTLE."

WILLIAM BOYD

William Boyd
Author
Interview, page 117

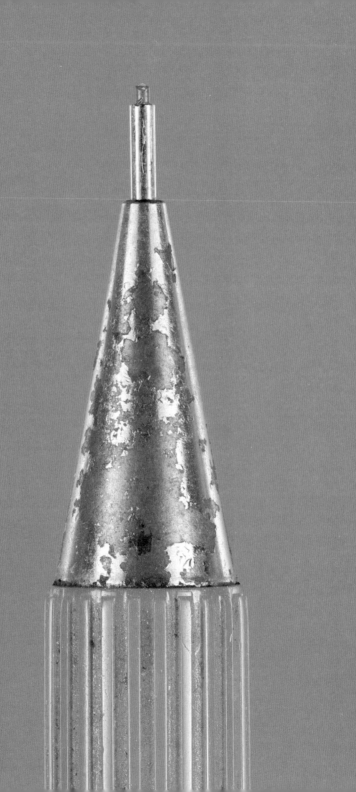

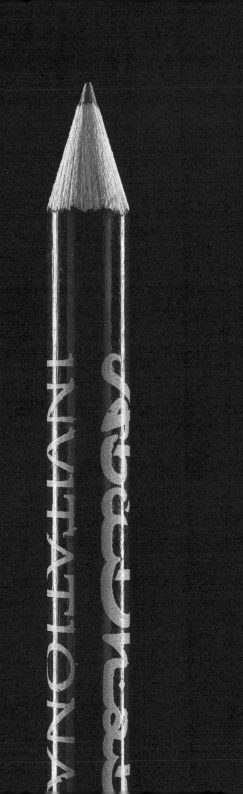

< Rory McIlroy
Golfer

Kengo Kuma
Architect

Charlie Green
Makeup artist
Interview, page 120

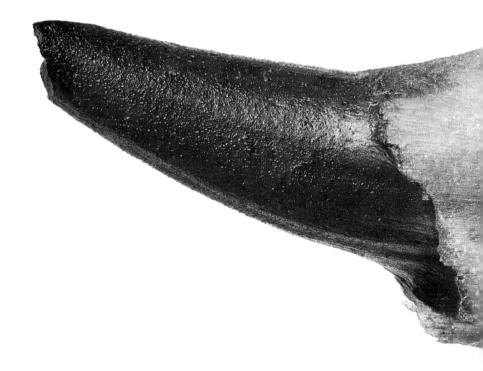

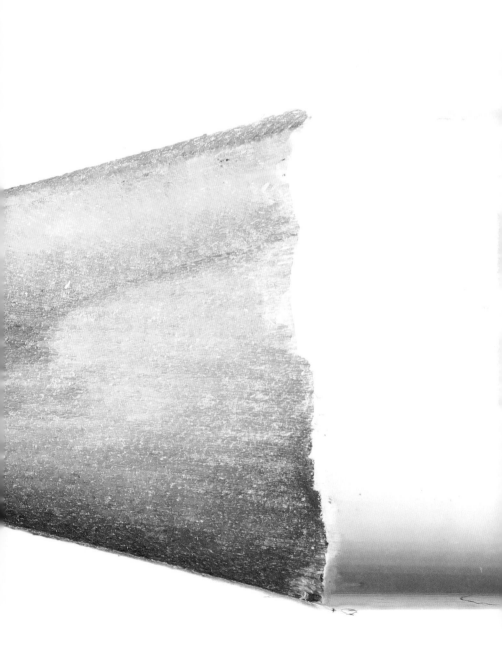

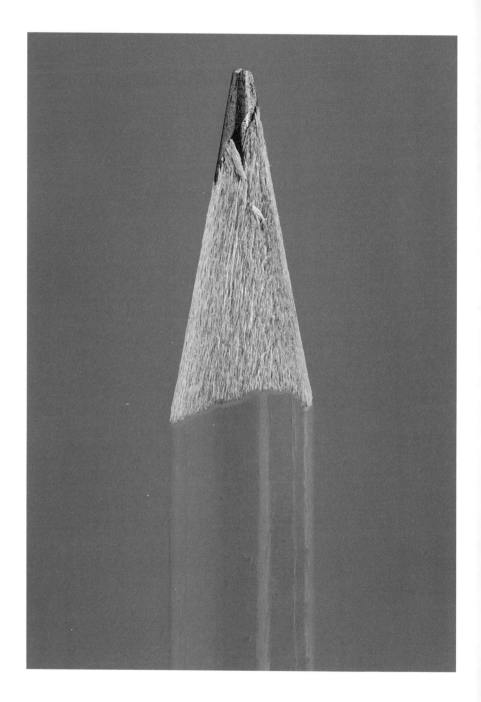

Kate Rhodes
Author

Tom Stuart-Smith >
Landscape designer

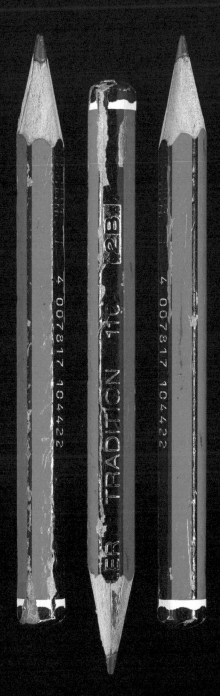

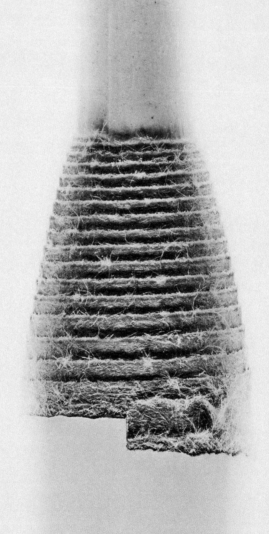

"THE PENCIL LETS US TALK WITHOUT WORDS."

JAY OSGERBY

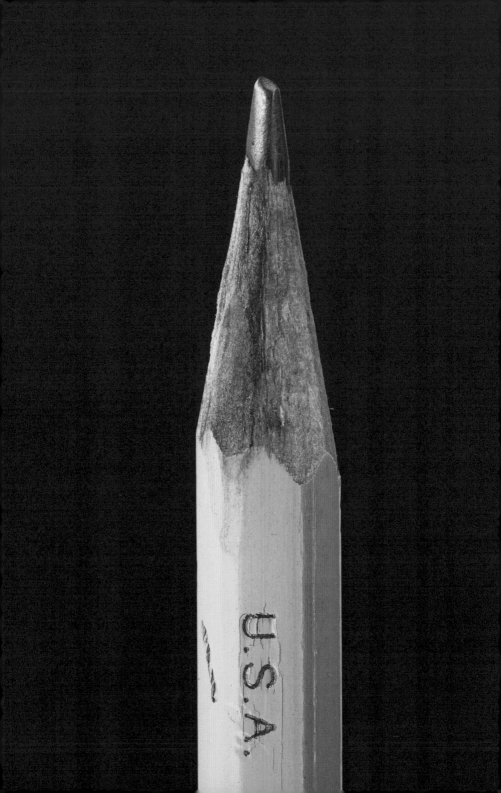

< Nigel Parkinson
Cartoonist
Interview, page 124

Sir Peter Blake
Artist

Sir Norman Foster

Architect

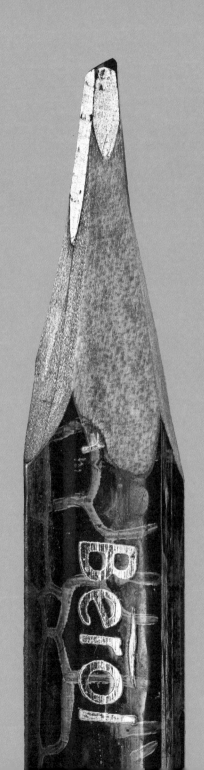

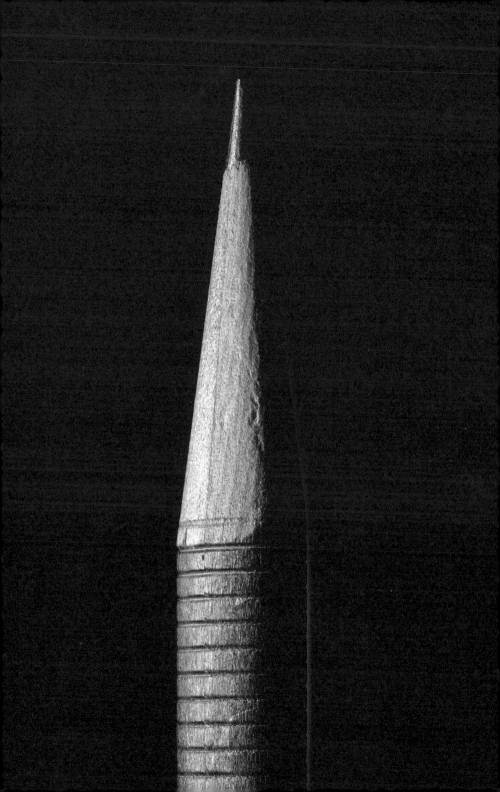

"A PENCIL IS AN INSTRUMENT OF ENDLESS VERSATILITY. IT CAN BE SOFT AND TENTATIVE, BUSY AND INQUISITIVE, HARD AND PROBING, SMUDGY AND MYSTERIOUS."

POSY SIMMONDS

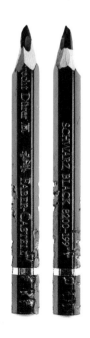

Posy Simmonds
Cartoonist

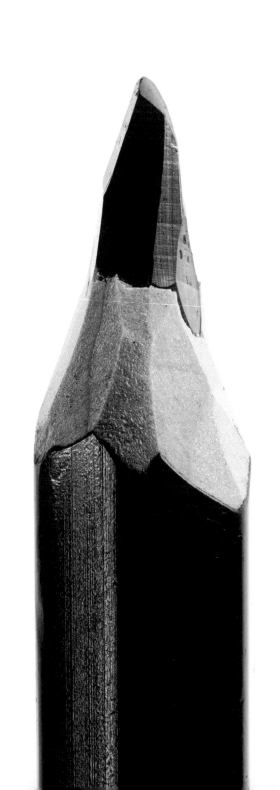

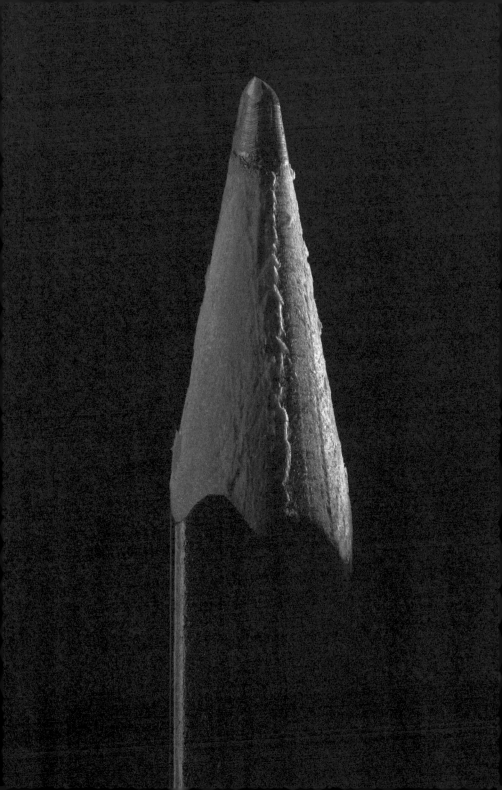

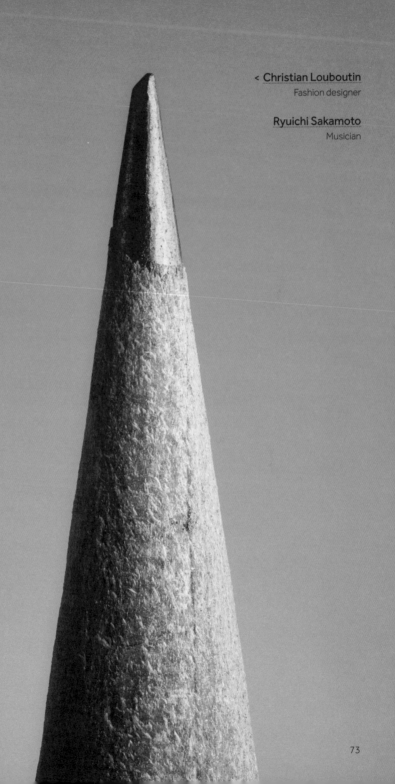

< **Christian Louboutin**
Fashion designer

Ryuichi Sakamoto
Musician

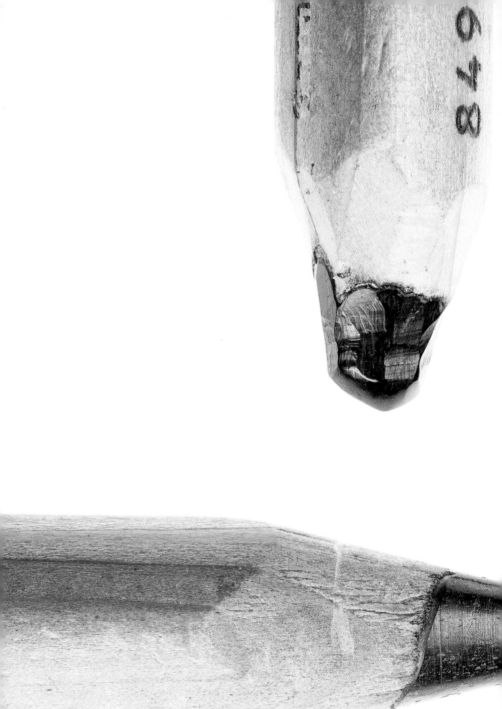

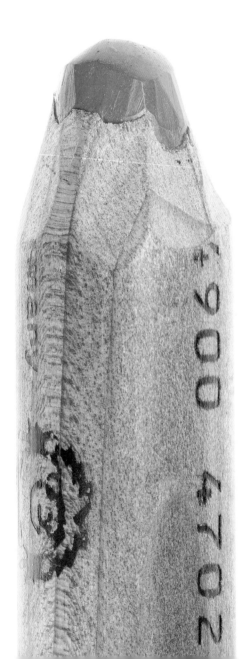

"WHAT I LOVE MOST ABOUT THE PENCIL IS HOW LITTLE IT HAS CHANGED OVER THE LAST 400 YEARS."

SEBASTIAN BERGNE

Sebastian Bergne
Industrial designer
Interview, page 131

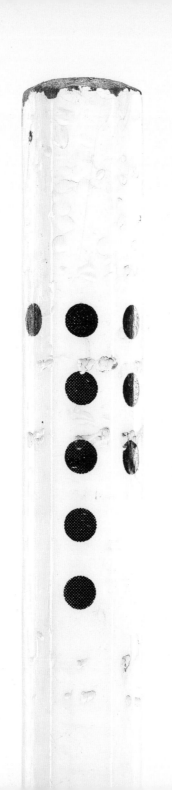

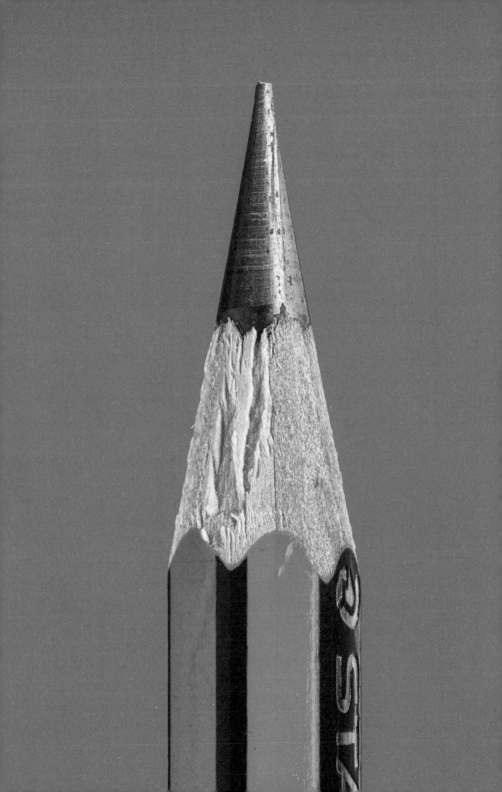

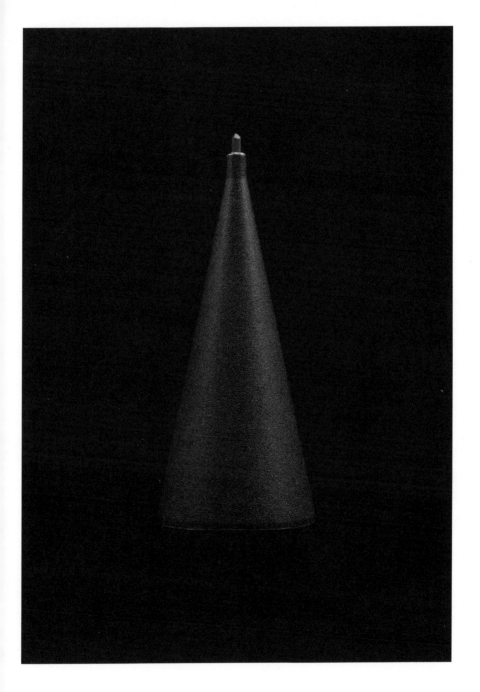

< Anne Fine
Author

Kenya Hara
Graphic designer

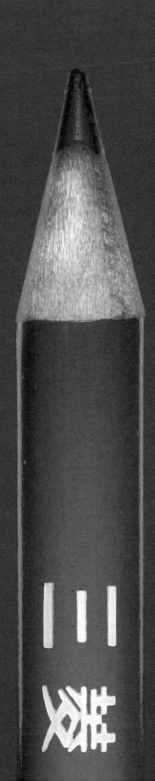

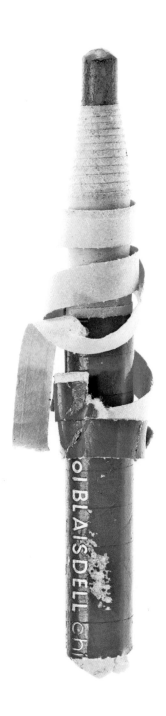

< Masayoshi Sukita
Photographer

David Montgomery
Photographer

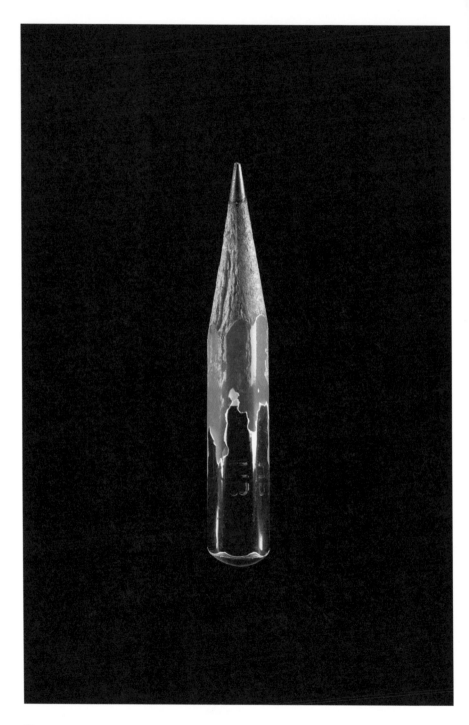

"I USE MY PENCILS UNTIL THEY ALMOST DISAPPEAR ..."

STEPHEN WILTSHIRE

Stephen Wiltshire
Architectural artist
Interview, page 130

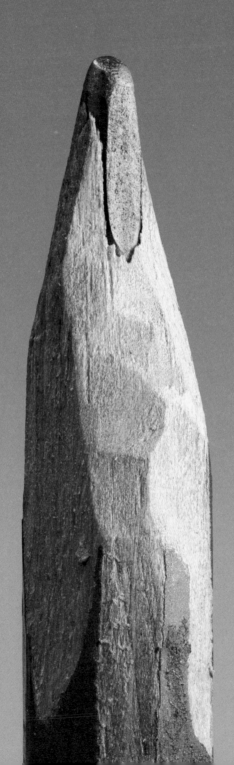

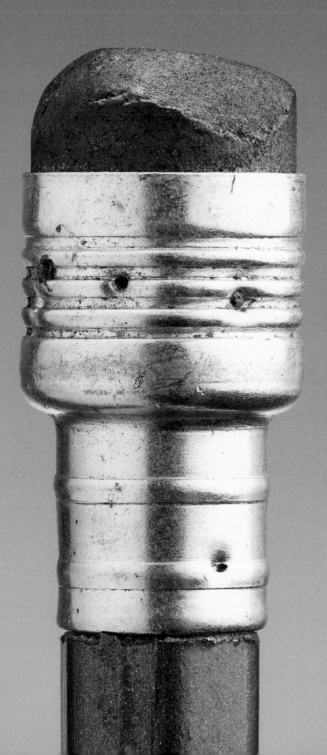

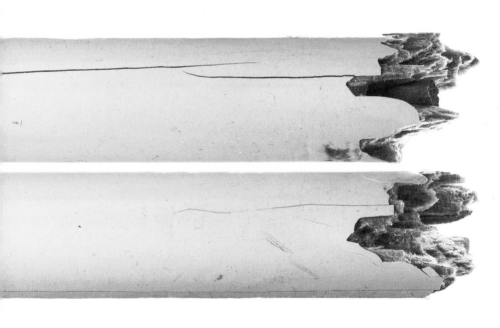

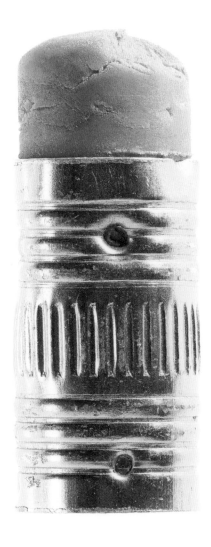

"A SIMPLE WOODEN
PENCIL IS BEAUTIFUL ...
OFTEN THE BEST DESIGN
IDEAS ARE THE SIMPLEST."

SIR PAUL SMITH

Sir Paul Smith
Fashion designer
Interview, page 138

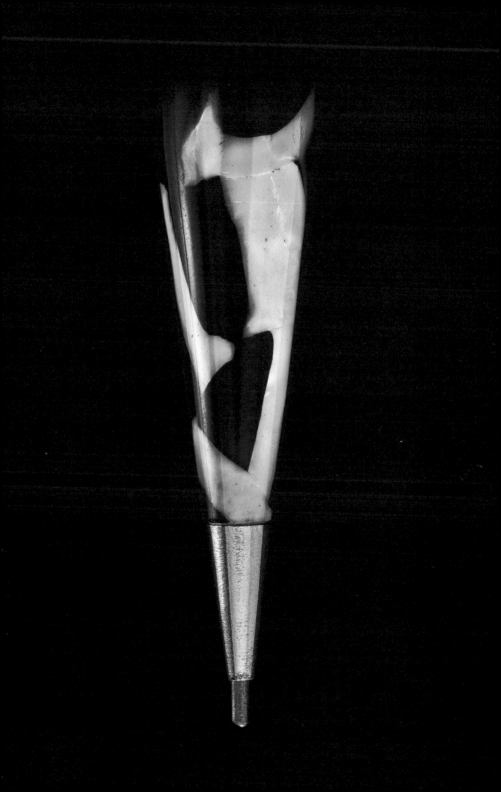

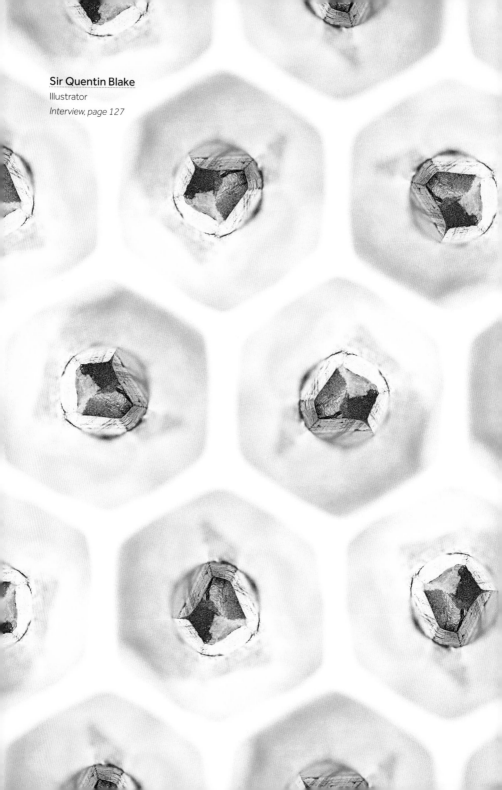

Sir Quentin Blake
Illustrator
Interview, page 127

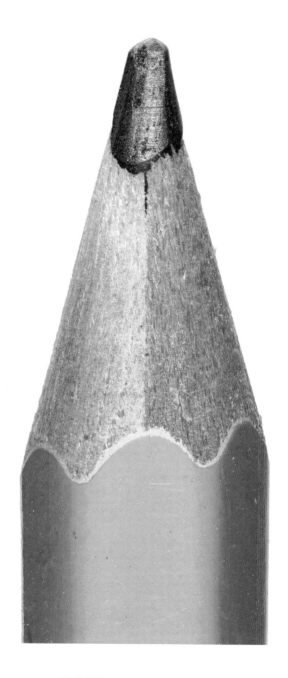

Anna Jones
Food writer
Interview, page 132

Keiichi Tanaami >
Artist

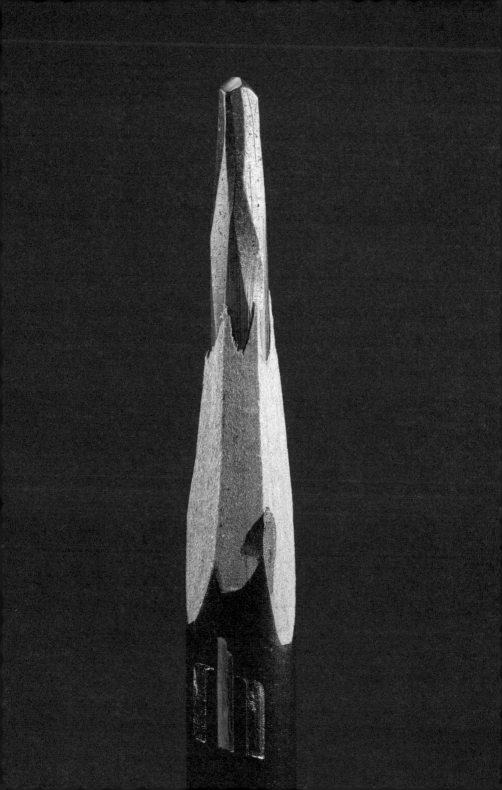

"A PENCIL IS LIKE A LANGUAGE, YOU CAN USE IT WITHOUT THINKING ABOUT IT."

IAN CALLUM

Ian Callum
Car designer
Interview, page 134

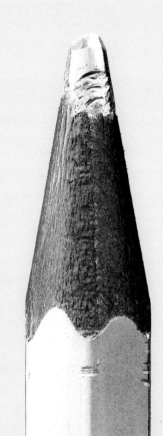

Shadow play

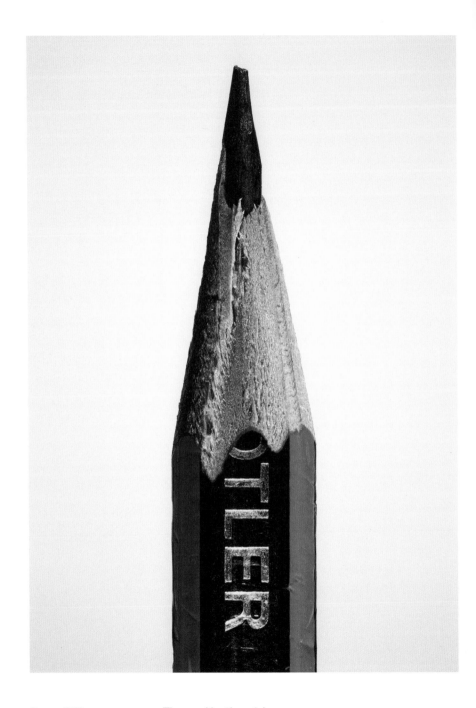

Dougal Wilson
Music video and
commercial director

Thomas Heatherwick >
Designer

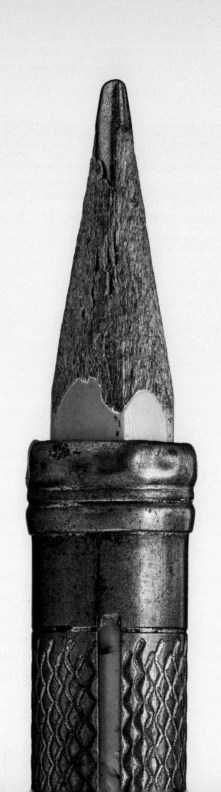

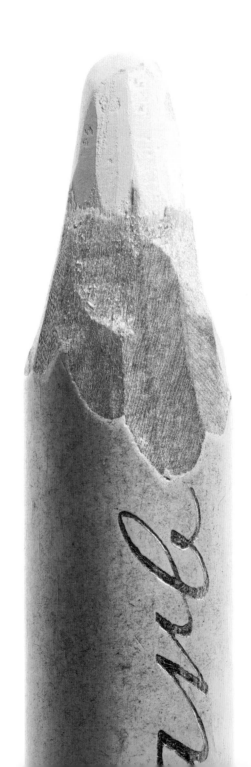

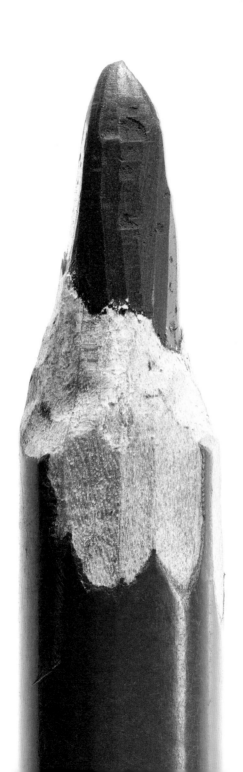

Julia Quenzler
Court artist
Interview, page 136

Andrew Gallimore
Makeup artist

Christopher Reid >
Poet
Interview, page 139

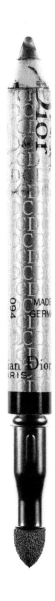

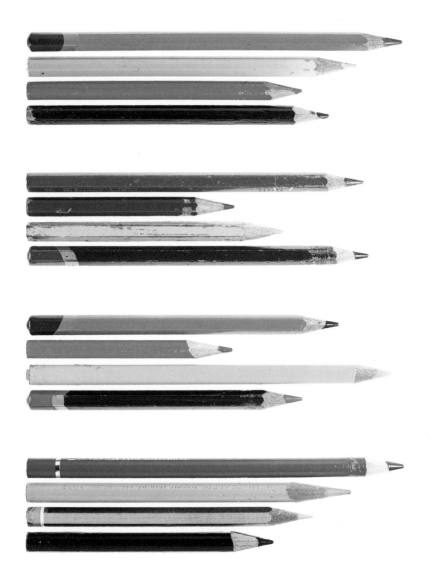

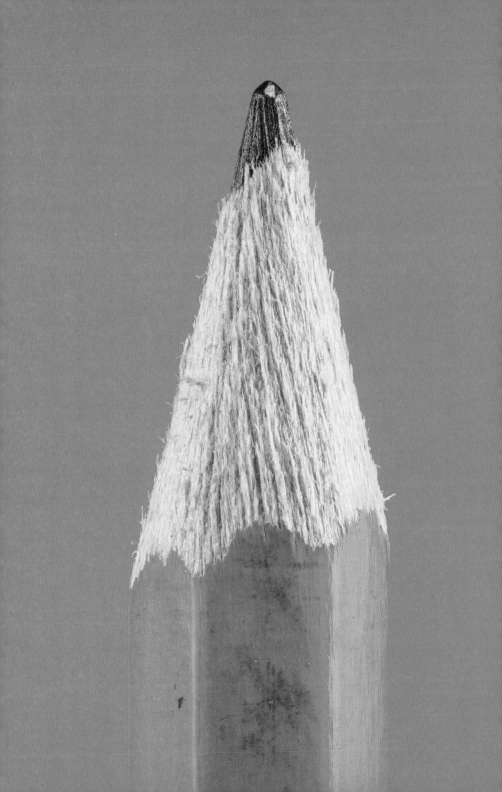

"WHEN I DESIGN
I ALWAYS ENDEAVOUR
TO CREATE SOMETHING
BEAUTIFUL YET PRACTICAL,
AND THAT, IN ESSENCE, IS
THE PENCIL ITSELF."

SOPHIE CONRAN

Sophie Conran
Interior designer
Interview, page 140

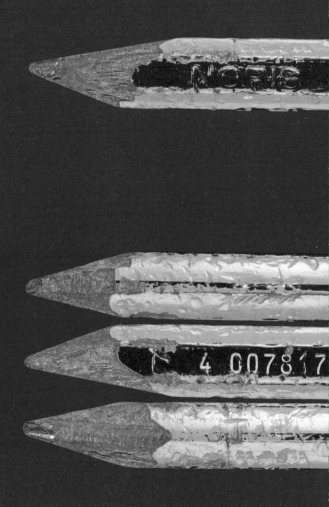

David Shrigley
Artist

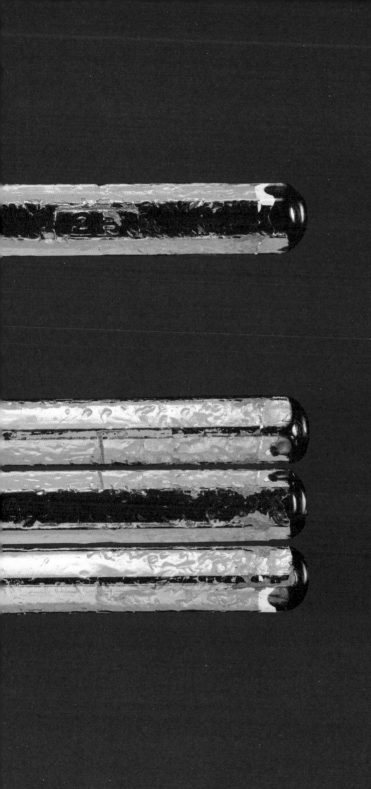

INTERVIEWS

DAVID BAILEY

David Bailey is widely acknowledged as one of the founding fathers of contemporary photography, having shot some of the most iconic portraits of the last five decades. His interests extend beyond photography to commercials, film, painting and sculpture.

The red pencil, like the red pen, is an editor's tool. With it, you refine, retune, select, cut. Do red lines have any special place in your aesthetic or view of the world?

We use red, yellow and white. The first time I mark up it'll be in red, the second time probably in yellow, then in white. The red pencil in the photograph [see page 14] was the closest to hand.

So you're a practical man?

When it comes to pencils I am very practical, yes. They keep breaking, I'm always sharpening the things. Maybe it's part of the pencil's charm that it breaks.

Is your red pencil a channel for creativity?

No. It's a by-product, there's no magic in it. It's a functional thing, like a camera or any machine. It's primitive. It does its job, like gaffer tape.

How does your pencil work change between different media and disciplines such as painting, sculpture and photography?

In my art, I only use pencils for drawing. I make photographs from life and drawings from my imagination. It'll just be an idea I have for a sculpture or a painting: sometimes with drawings you can explain things to yourself better.

Like you, Walt Disney was a fan of the red chinagraph pencil. Do you feel a kinship with Disney's working practice?

No, no. Disney was a genius. Anyone who could make a mouse sing and dance for the first time in history is pretty extraordinary. I wish I'd thought of that.

Is there anyone you'd have liked to watch at work?

Not particularly. I like Picasso's pictures but I wouldn't want to watch him slave over them.

Picasso is rumoured to have said, 'If they took away my paints I'd use pastels. If they took away my pastels I'd use crayons. If they took away my crayons I'd use pencils. If they stripped me naked and threw me in prison I'd spit on my finger and paint on the walls.' Do you agree on the status of pencil work as a relatively lowly, last-ditch art form?

No, it can be art in itself or it can be a doodle. The pencil is only as good as the person using it.

Last words on the subject?

If you want to get ahead, get a pencil and get a fucking pencil sharpener.

NO INK ACCIDENTS — PAPER AND GO!

YOUR PENCIL IS ALREADY POWERED UP — NO BATTERY NEEDED

NO NEED TO DOWNLOAD A FONT —

Pencils
Rock!
Rock
yours

David Shilling
2016

LIGHT AND SHADE ARE AUTOMATIC

DAVID SHILLING

David Shilling's extravagant, architectural hat designs are a staple fixture at Royal Ascot's Ladies' Day. In the early 1990s the focus of his work shifted towards painting and sculpture.

What have you created with the pencil in the photograph [see page 25]?

Just the usual day-to-day stuff. I am too fond of my best pencils to part with a real favourite. Even the box I used to send it in was not so much a great design decision, more an answer to a time-sensitive need. That may be how great art is born: the magic mark of the accidental.

HB or 4B – what is your preferred grade of pencil?

That is nowhere near the half of it! There is that happy-go-lucky side of me that loves to take a chance, but not when it comes to choosing a pencil.

The pencil itself is considered by many to be an iconic design. Have you ever incorporated pencils into your designs or your artworks?

I never think of the pencil as an iconic design because there are so many shapes and sizes, lengths and breadths. The decoration or lack of it should not influence one but it does – the equivalent of go-faster stripes on a Lamborghini. But with pencils, often less is more.

Your work is distinguished by its often extravagant vision. Where does the humble, mass-produced pencil fit into your scheme of reference?

Well I don't think of the pencil as humble for a start. It is a very sophisticated instrument. Anyone who has had to sharpen a pencil, or has had to choose one in a real art or stationery shop, knows this. It is more complicated than ordering coffee in America.

What have pencils allowed you to do that some other writing or drawing instrument might not? Where can we see the fruits of your pencil work?

Remember I was never at art college, never had formal training, so I am no draughtsman. I am self-taught and my drawings are largely for my own reference, very simple aids for my work. There are hundreds of them in my archive.

Has a pencil ever led you astray – into theft, rudeness, graffiti, inelegance or worse?

When I was really young my mother and I were having lunch at the Dorchester Hotel and John Lennon was there. We chatted and I noticed he had drawn a couple of characters on the linen tablecloth. When he'd left I asked the waiter if I could take them, then I cut them off the cloth with a knife, so it was not stealing. Maybe if he had said no I would have tried to take them anyway. Afterwards I cut the remnant in two and gave one half to my girlfriend of the time. Back then a humble pencil drawing was enough; now they tend to want apartments and cars.

Tell us about a favourite pencil-related moment.

I was at the blockbuster Leonardo show at the National Gallery. I followed a pair of tweed-covered ladies into the room of 'cartoons', and one of them turned to her friend and loudly exclaimed, 'Let's go to the next room, there are just a load of drawings in here.' I will never be fazed by any criticism of my own work, if this can happen to the maestro Leonardo!

MICHÈLE BURKE

Makeup designer Michèle Burke is particularly known for her film work. She has been Oscar-nominated for Best Makeup six times, winning twice for *Quest for Fire* in 1983 and *Bram Stoker's Dracula* in 1993. She is also a two-time BAFTA winner.

How do you like to work with pencils?

Every idea I have starts with a doodle or something on a page with a pencil. I particularly like the pencil in the photograph [see page 26] because it's ergonomic and it's flat. When I pare a pencil like that with a blade as opposed to a pencil sharpener, I can do more with it. I can hold it in different ways and get different shading results and also – very importantly – I can rub it out if I don't like it.

Did you train in art or at a makeup school?

I wasn't officially trained, with the result that I learned new techniques by myself. When people looked at my work they just saw something different.

I wanted to ask you about Gary Oldman as Dracula. Where did the inspiration for this design come from?

Francis Ford Coppola and Eiko Ishioka (the costume designer) said to me, 'we want this Dracula to be different'. Then Eiko said, 'I want "East meets West".' I had these pictures in my house of Native American women, Hopi Indians, wearing shawls, with their hair twisted into this hairdo. It created a beautiful silhouette. I kept thinking about kabuki and trying to merge the two. I started doodling shapes that I liked. I presented at least three or four designs. The design opposite was the one that was accepted.

Could you tell me a little about drawing on skin rather than on paper?

Drawing or painting on skin is different because you already have a shape which you're sometimes trying to alter or fight against. Perhaps you're lining to make someone's eyelid look bigger when in fact it's smaller. You have to do it in a very subtle way because you don't want that to show up on screen. So I'm drawing in a very different way than I would on paper or canvas.

And your canvas, your subject, is watching you …

Exactly. The worst is if they're talking on the phone, or you have to keep slowly lifting their chin up because they're reading their phone. I did some very complicated tattoo work on Tom Cruise while he was with his voice coach. His whole body was moving, I was working on a moving target. So when I'm drawing with a steady pencil and a piece of paper, it's sheer bliss.

What do you love most about drawing with a pencil?

I love it because it's part of me. I have a pencil with me at all times and it's instant and it's organic and it's direct. It's like not eating a packaged dinner, but instead making it yourself. I find if I'm just doodling, I look at the doodles later and I think, okay, that could be the start of something there – and then out of it will come a picture.

You don't have a favourite?

The one I use all the time – probably the cheapest thing in the market – is a yellow Papermate sharp writer No.2. I always have one of those because that's the one it's easy to write my agenda with. I use it for drawing too. It always starts with the doodle and the piece of paper and pencil. That's the genesis of everything.

NADAV KANDER

Renowned photographer Nadav Kander is especially known for his portraits and landscapes. His work is featured in major collections worldwide, including the National Portrait Gallery in London.

At what point do you use pencils in your work?

Only very briefly, when marking up contact sheets.

Tell us about someone whose pencil drawings you admire, and why.

I have such admiration for people who can visualize and make others visualize by drawing. When we were working on our house here in London, I remember being so inspired, and finding it incredible that our architect could draw almost in three dimensions in perspective, on the spot.

I've been more inspired by painters and artists than by photographers. For example, Jamie Foubert is a terrific architect who makes beautiful sketches. Or William Kentridge, whose filmmaking involves charcoal and smudging, he creates really beautiful work. Or Alice Neel, the American artist, or Peter Howson, the painter.

An early memory is going to the Picasso Museum in Spain. My sister, who was wonderful at drawing, burst into tears when she saw Picasso's incredibly delicate drawings, his schoolbooks, drawings he'd made when was only seven. She was the artist in our family, but she saw how far behind she was, compared to Picasso.

I've always loved showing my students how Matisse would draw with one continuous line. The outline, the hair, everything. I'm sure I'd be able to recognize that person on the street, just from that one line.

How about your own artistic endeavours?

Much as I admire the subtlety of drawing, the graphite, the shading, I don't draw at all. Unlike my sister, I've always been pretty bad at drawing. I didn't see my inability to draw as a barrier to creating art – I didn't see photography as an art, I saw it as a craft. My skill is knowing when a photograph is good or bad. But I probably know whether something's good or bad because I can't draw.

My work is often inspired by artists. In my Bodies series, the forms came from Jean Arp, but not consciously. Once I saw what I was doing, then I recognized the influence, and looked at Jean Arp as I carried on.

WILLIAM BOYD

William Boyd has received worldwide acclaim for his twelve prize-winning novels, among them *A Good Man in Africa* (1981), *Any Human Heart* (2002) and *Restless* (2006). He has also penned several screenplays.

Where does the pencil fit into your creative process?
I used to write my novels in pencil but I stopped about six novels ago as I became worried about the permanence of the manuscripts – how the graphite might fade in time and become harder to read (I have minute handwriting) – so I shifted to pen. I still use pencils a lot but mainly for jotting down notes.

What have you created with the pencil in the photograph [see page 54]?
This pencil probably 'wrote' five or six novels over a period of fifteen years or so. I was always searching for the perfect pencil and then found it in this Faber-Castell propelling pencil (with a 2.2 mm lead). It was for me the perfect writing implement for many years, until the worries about graphite fading set in and I made the shift to ink.

Why a mechanical pencil and why a pink one? Is this pencil special?
You don't need to keep sharpening the lead with a mechanical pencil, a huge advantage if you're using it to write rather than draw. This pink one succeeded a black one that I bought and then lost. This line – anyway, this model – of Faber-Castell pencils has been discontinued. The only one I could find was a pink one, funnily enough. I wouldn't have picked pink – I would have picked black – but I had no choice. It's the last of its line and consequently it is unbelievably precious to me.

Are pencils for every day?
Of course. I always carry a mechanical pencil, but in my study I have dozens of other pencils (for drawing and sketching).

Which tools do you use for work and which for leisure?
I don't draw as much as I used to, which is a shame, so it's mechanical for work and old-fashioned for art, in my case.

Tell us about a favourite pencil moment, true or fictional.
In my case it has to be fictional. In my novel *Restless*, the central character, a young woman spy called Eva Delectorskaya, kills a man instantly by driving a sharp pencil through his left eyeball. I checked with an eye-surgeon that this was in fact possible. She wanted to kill him, not just blind him.

Has your pencil work changed over time?
No, not really. Though I actually use coloured pencils a lot for drawing, inspired by David Hockney's coloured-pencil work, which is absolutely wonderful (and rare).

What have pencils allowed you to do that other writing or drawing instruments might not?
Infinite variation is the answer, I suppose, as artists have discovered over centuries. The 'line' a pencil makes can be so many things and gradations of shading can be astonishingly subtle.

MATTHEW JAMES ASHTON

Matthew James Ashton is the vice president for design at LEGO, having started working for the company at its headquarters in Denmark fourteen years ago. He played a leading role in the creation of *The LEGO Movie*.

Can you tell us a little about the pencil in the photograph [see page 53]?
It is just a very simple mechanical pencil. It is perfect and practical for all my needs. I carry a pencil around with me in my bag as I never know when the next idea (good or bad) is going to pop into my head! I've drawn a lot of sketches of LEGO Minifigure characters with it. Several of these have come to life as toys and/or characters for upcoming LEGO movies.

Where does the pencil fit into your creative process?
If I have a specific design or vision in my head of what I think could make a great character, I will do a quick doodle and hand it over to our graphic designers and sculptors who then take it to the next level.

Perhaps you could tell us a little about the delightful sketches you sent in [see opposite page]. How did the shark guy and the hot dog guy start out?
Anything that is a little bit quirky or silly comes from me. Usually I might only do one sketch of each character I am involved with and then I hand it over to my team for them to bring it to life as a real toy.

Describe your perfect pencil, real or imaginary.
When I was growing up I had a terrible habit of chewing on wooden pencils, which is one of the reasons why I switched to mechanical pencils – it's difficult to look like a professional when you have a gnawed-at, slobbery pencil hanging out of your mouth. The kid version of me would have loved

flavoured pencils even more, in a range of colours that not only smelled like ice creams but tasted like them too. As an adult, I am pretty happy with the pencil I have, although I would love it if the lead never broke and lasted forever.

Are there particular artists whose drawings inspire you?
I remember reading Roald Dahl's books as a kid, like *The Twits* and *George's Marvellous Medicine*, and thinking, 'Why are these drawings so scribbly? I could do much better than that!' As an adult I see Quentin Blake's work in a whole new light and am amazed by how much expression he conveyed in such loose, simple drawings.

Have you ever used a pencil for an unusual purpose?
When I had a longer fringe in my Britpop days, I may have knotted a pencil into it to keep it out of my eyes while I was drawing with another one.

Finally, please tell us about any other favourite pencil-related moments from your career.
During my very first week at The LEGO Company, we had free rein to create whatever we wanted in LEGO. There was a very special little lady I drew during that week, Wonder Woman! She was my idol. It actually took twelve years before we finally got to launch her, but I didn't give up on that little pencil sketch I drew the first week I arrived.

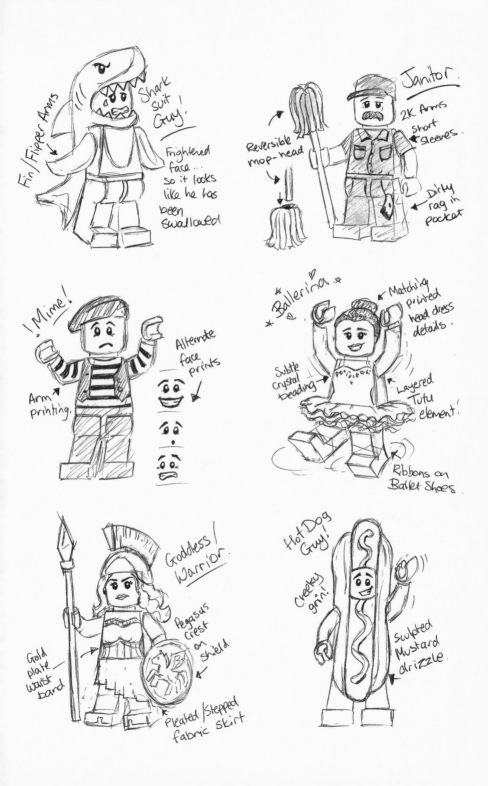

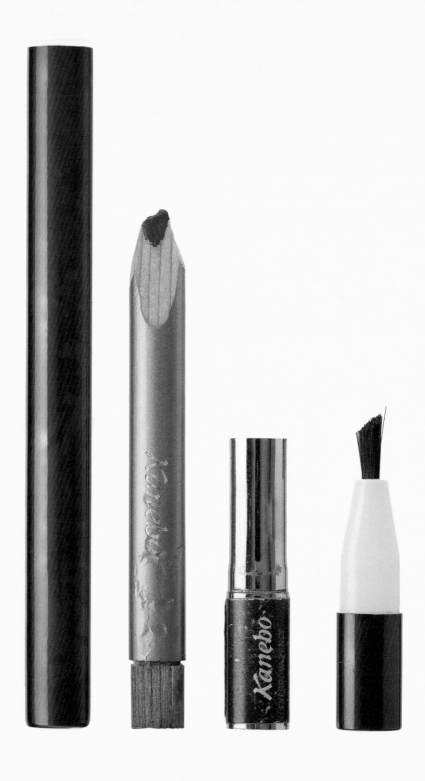

CHARLIE GREEN

Makeup artist Charlie Green has been painting the faces of the world's most famous celebrities and fashion models for over twenty years. She also works with high-profile beauty brands on developing new ranges.

Please tell us about some looks you've created with the pencil in the photograph on page 58.
As a makeup artist this pencil got more use from the heavily pigmented black 'warped' end as I do love a smoked-out eye. It also has a white end, which is a lovely addition. It's super-useful for lining the lower rim of the eye to brighten a wide-awake vision. Sometimes I just use the black crayon to fuzz all over the eyelid – and underneath too – layering over it with charcoal eyeshadow for an intensive punch.

And how about the pencil pictured opposite?
This discontinued Kanebo eyebrow pencil is very sadly missed from my makeup kit. The sheer oblong lead made for the best brows ever.

How is drawing and painting on a person different from drawing on paper or canvas?
As a makeup artist I am part of a big team to create an amazing image. As the artist who is so intimate in the face of her model, I am her therapist, her guardian, her confidence booster and the one who helps her get a cab home. When the day is over I have to look out for my girl!

When you started out, you had to create lots of products yourself. Today shops are full of an incredible range of products. Is it important to you to have the best pencils and brushes to work with? Or can you create amazing looks with basic tools?
I did create many home-made products to achieve the effect I was after. Today we are spoiled by the glut on the market of amazing tools available for makeup artists. Sadly, I think this has diluted the talent and artistry in our business.

Can you describe your perfect pencil?
That's not possible. We need variety. As an artist I need every type that performs well. There is no perfect pencil, yet there are many perfect pencils ideal for the job in hand.

Finally, do you ever use your pencils for any unusual purposes (to scratch an itch, as a weapon, to perform an emergency tracheotomy, etc., etc.)?
Does being without a corkscrew and pushing the cork into the bottle with a pencil count? It was in a bathtub to wash away the mess on a job in Monaco ...

JAY OSGERBY

Jay Osgerby founded the industrial design studio Barber & Osgerby in 1996 with his partner Edward Barber. Their work is held in museum collections around the world.

Where does the pencil fit into your creative process?

A lot of our work is exploring ideas, which we achieve through drawing. Everything we do begins with a sketch. The nature of the drawing changes a lot. At the beginning, you can flesh out an idea quickly with a drawing, it's instant. Then later, working with other countries, the pencil becomes a vital form of communication. It lets us talk without words. Languages aren't our strong point, but we can communicate to an engineer or a technician with a drawing.

What have you created with the pencil in the photograph [see page 62]?

The pencil in the photo is used for drawing and marking fabric, for working on upholstery projects. We used these pencils in 2015 when we were working on our pilot chair, in Italy. They're great for drawing the seam lines, for turning a corner in fabric. They're fantastic tools.

Are you particular about having the right pencil?

I could draw with literally anything. If you were stuck on a desert island, you wouldn't give a damn. I have no need for fanciness in my pencils! I wouldn't describe my work as artistry, but drawing is a tool I absolutely depend on for communication.

When did your love of drawing begin?

I drew nonstop as a child. Not that I produced great drawings, but I was always doodling, playing with technique. Later I really enjoyed discovering the conventions of drawing. For me drawing was always about trying to understand and explain an object.

Do you think that beginning a design on paper, as opposed to working digitally, changes the end result?

There's a rigour that comes from drawing with a pencil and paper that relates back to thousands of years of architecture. Nowadays, things are being designed on computers – contorted, twisted forms that don't always feel that friendly, or make people feel good.

Do you draw or doodle for pleasure, or just for work?

Drawing isn't really working. It's a fun thing to do. There are so many different modes of drawing, it's the difference between writing a list and writing a novel, that's how much range you have with a pencil.

Do you think the pencil will ever become redundant?

If you want to think about how important the pencil is, just think of its history. Graphite was found in Cumbria, so the pencil was really invented there. Originally it was used for marking sheep, so everybody knew whose sheep were whose. But during the Napoleonic wars, the British government banned the export of graphite, and suddenly Napoleon couldn't make his battle plans – that's how important pencil can be. In fact, the export ban was what led Conté to develop pencils using powdered graphite and clay. He was basically using leftovers. So, yes the pencil will stick around. It's fundamental.

JOHN PAWSON

Renowned for the simplicity and minimalism of his designs, John Pawson has completed a number of architectural and interior projects, including the new premises of London's Design Museum.

Where does the pencil fit into your creative process?
I am not a great sketcher, although I do draw simple cartoons to get my ideas across. I use my pencils as much for words as for drawing. I am a great believer in notes and lists – we remember far less than we think we do.

You have said, 'I'm happiest, as I was when I was a child, with crayons and a bit of paper. One of my biggest treats when I was a boy was to go to my father's factory's stationery room, with endless supplies of pencils, reams of papers, notebooks.' So having pencils and paper in hand can make you happier than a camera, or anything else for that matter?
I am happy when I am thinking clearly about something. Having time and being in a calm environment play a part in this, but a pencil and a blank sheet of paper help open up the mental space I need, regardless of other circumstances.

Tell us about someone, living or dead, whose pencil drawings, designs or notebooks you admire, and why?
I never met Mies van der Rohe, but no other single individual has had a greater impact on my architectural thinking, with the exception perhaps of the Japanese designer Shiro Kuramata. Van der Rohe's drawings provide unparalleled insights into the way he subjected the first ideas for a project to a rigorous process of examination and re-examination, with something to be learned from even the broadest of his pencil strokes.

Where would I find the pencils in your ideal interior workspace? And where, if anywhere, in your ideal leisure space?
I never really make a distinction between work and leisure spaces. I work everywhere. Consequently I keep pencils everywhere.

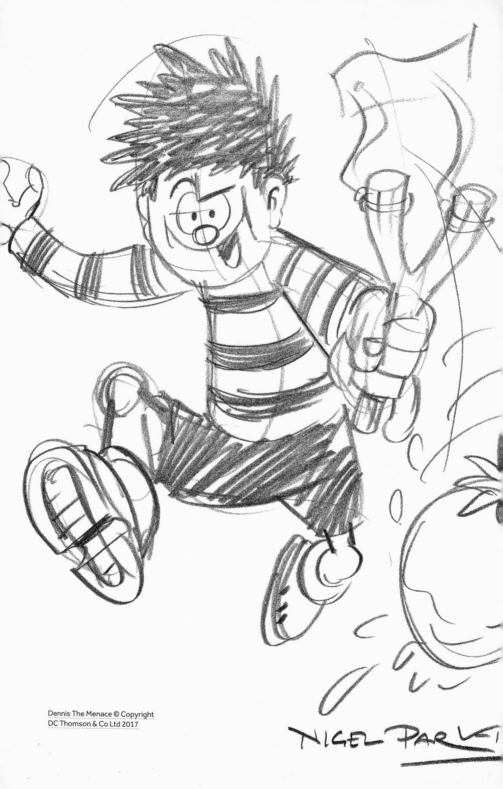

NIGEL PARK

NIGEL PARKINSON

British cartoonist Nigel Parkinson draws Dennis the Menace and Minnie the Minx, among other characters, for classic comics *The Beano* and *The Dandy*.

Where does the pencil fit into your creative process?
It's the start of everything. If I'm writing a story, I begin with a rough pencil sketch and decide what the dialogue will be later. If I'm drawing from someone else's script, I rough out each panel on the page very lightly. A whole page can take fifteen minutes until I'm happy with the layout, the action, the expressions. Then I put detail into the drawings with pencil. Finally, I finish the drawing with pens.

HB, 2B ... or what?
HB. I began with 3B but eventually ended up with HB. I don't need a finished illustration using pencils, just a guide for my final black line work.

Are your pencils for everyday use or for special occasions?
Everyday and every day!

What have you created with the pencil in the photograph [see page 64]?
I use that pencil to block out every page I draw! I was drawing a Dennis the Menace *Beano* page the day the picture was taken.

Do you and your pencil take a line for a walk or do you find it can work the other way round?
The pencil marks the page where my eye has seen the image I want.

How has your pencil work changed over time?
In my early career I overworked the pencil stage, spending maybe more than half the total work time pencilling, re-pencilling, erasing. Now I use the minimum number of pencil strokes to realize what I need. But that's a result of experience and confidence more than a deliberate method.

Tell us about a favourite pencil-related moment.
As a young cartoonist I asked an editor for a new pencil as I was down to the last inch of mine, and he held it up and said, 'There's another two pages in that!' During World War II, the *Beano* and *Dandy* offices issued their artists with metal pencil holders so that the pencil could be sharpened even more. It probably saved about a penny a week.

Has your pencil ever led you astray – into theft, violence, disfigurement, graffiti or worse?
No, the pencil is an extension of me and does what I want!

Do you chew?
Dear me, no.

NICK PARK

Animator and director Nick Park is the creator of many well-loved characters including Wallace and Gromit and Shaun the Sheep. He is the winner of six Oscars.

What have you drawn with the pencil in the photograph [see page 68]?

This is the pencil that was used for all the rough first stage drawings for the Wallace and Gromit film *A Matter of Loaf and Death*.

2B or not 2B?

Mostly 2B, but I sometimes use softer pencils.

What do pencils allow you to do that you couldn't do on a computer?

Draw. I am always happier when working with pencils and feel more in touch with the artwork I am making. There is a naturalness of texture and I feel far more in control.

When drawing characters, where do you start?

With the eyes.

Drawing on a computer tablet can never compare with a real 4B and paper it's bliss

SIR QUENTIN BLAKE

Sir Quentin Blake is an English cartoonist, illustrator and children's writer, known for his collaboration with writers such as Joan Aiken, Michael Rosen and, most famously, Roald Dahl.

Please tell us about some of the drawings you've created with your magic pencil [see page 92].

Several years ago I helped to organize an exhibition of present-day British illustrators at the British Library. We called it Magic Pencil and we had those words printed on pencils, for sale in their shop, which drew a line in three or four colours. I enjoyed using them and later on I had the idea of using them to make the sky drawings in *Angel Pavement*.

Do you have a favourite type of pencil?

I mostly use scratchy pen nibs with black or sepia ink. I have just illustrated Russell Hoban's *Riddley Walker* for the Folio Society and that is all drawn with an assortment of quills. It is very gloomy and primitive and those sometimes rather unpredictable marks seemed to me rather appropriate. My favourite pencil is a black watercolour pencil. I draw with it and then work into it with a wet brush, with (I hope) interesting effects. The whole of a book of drawings called *The Life of Birds* was done in this way. Another favourite pencil is the black China Marker. Both of these two have effects that at one time would have been achieved by lithography.

The pencil has been with us since the sixteenth century. Do you think it will stick around for another 500 years?

I suspect that what one might call an ordinary pencil will be with us for a very long time, not so much for its visual effects but for the ease with which one can make visual notes and, in a sense, do thinking on paper.

Your drawings communicate so many emotions: joy, mischief, wonder, sadness. Do you feel the emotions of the characters you're drawing as you draw them?

This is a different kind of question and an interesting one from the point of view of illustration. I don't, in fact, feel the emotions of the characters, although – I am not quite sure how to describe this – one tries to mimic or identify with them, but of course you are thinking about a number of other things at the same time, such as the look of what you are drawing, its disposition on the page, what the implements you are drawing with are doing and the sequence of images. The attempt to make your characters look as though they are feeling the emotions suggested by the book is something quite instinctive and comes into the drawing sometimes without your quite knowing what is happening.

In *Angel Pavement* you write, 'When you start drawing, you can never be quite sure what is going to happen next, can you?' Do you surprise yourself when you're drawing?

Yes, sometimes you look back with an element of surprise at what you have drawn and I think also sometimes it is possible to draw feelings which you have not altogether identified.

PETER JENSEN

Danish-born Peter Jensen is one of London fashion's most cherished and recognizable figures. Educated at Central Saint Martins, he established the Peter Jensen brand in 1999 and has been showing as part of London Fashion Week since 2001.

Where do pencils fit into your creative process?
When I start drawing the new collection.

Did you always like drawing as a child? Can you remember the first drawing you made that you liked?
Yes. My grandmother kept all my drawings from when I was a child and I found them all when she died – I now have them in my house.

Has the way you draw changed over the years?
Yes, it has become much better and much closer to who I am as a person.

Do you use expensive pencils, or can you draw with anything?
No, I can draw with something I have had for years and years.

What do pencils allow you to do that you couldn't do on a computer?
I can't do anything on a computer except for writing emails, and looking up things on Safari, iTunes and iPlayer. That's it.

Please tell us a bit about your brightly coloured HAZZYS pencils [see page 74]. They look delightful.
They are! It was such a great surprise that they made them and, to tell the truth, I was way more excited to see the pencils than the clothing. They now live on my desk. Just to think that someone, somewhere, is writing something with my name on the wood – I love it!

You've been inspired by so many artists and art collectors ... Cindy Sherman, Barbara Hepworth, Peggy Guggenheim, to name a few. Please tell us a bit about how artists have inspired your work.
Well they come and go from having a place in the PJ world. The ones I get inspired by are also the ones I admire or would like to admire, I think it is very important that these particular names are all strong women in their own right. It all depends on who they are and how that ends up in my work.

If you could swap pencils with one person from history, who would it be?
Christina of Denmark, Agatha Christie or Philip Larkin.

No comments

STEPHEN WILTSHIRE

Architectural artist Stephen Wiltshire is known for his ability to draw accurate and lifelike representations of cities, sometimes having only observed them briefly first.

Can you describe how you use pencils?

When I see an exciting scene, I just use my pencil to draw a rough sketch in my sketchbook and finish the drawing later in my gallery with pen. I also often use pencils to do the outline and layout of my drawing before going over it with my pigment liners.

Do you have a favourite type of pencil? If so, why?

I use Staedtler pencils and pigment liners. They come in different shades and sizes, so I can add effects to my work easily.

Tell us about the first drawing you made that you were proud of.

I used to draw animals when I was very little, but my favourite drawing of a building is of St Pancras station and dates from 1982.

How do you make a drawing? Do you start with a sketch or an outline, or just begin with one detail?

Sometimes I draw the outline using pencil and finish the details with pen and ink, then rub off the pen work. If I want to add shading later I use my pencil again.

What is your favourite thing to draw?

I like modern cities, like London and New York. I like the chaos and order, the rush-hour traffic versus the square avenues. My favourite buildings are the Chrysler Building and the Empire State Building, and also Canary Wharf.

What's the longest amount of time you've ever spent on one drawing?

When I drew the Tokyo skyline on a 10-metre-long canvas, it took me nearly 10 days.

SEBASTIAN BERGNE

British industrial designer Sebastian Bergne describes his approach to design as 'making everyday objects special'. His designs include the Pencil Dice and the Kitchen Pencil.

How does using a pencil affect the way you think and create?

A pencil has the advantage of not being permanent. Even though I never use a rubber, the pencil is more forgiving and somehow most suited to changing and developing ideas.

Please tell us a little about how you came up with the ingenious idea of dice pencils ...

The Pencil Dice came about when I was wondering what might be printed on a pencil to make it useful. When I realized both pencil and dice had six sides, there was a lightbulb moment. The fact that the functions of the pencil and the dice make sense together meant that the idea stuck.

Can you remember the first pencil drawing you made that you were proud of?

It was a still life of a stripy t-shirt hanging on a doorknob, a not-very-exceptional school exercise from when I was about fifteen. What most satisfied me was that I spent two or three days working on a drawing that turned out how I intended. I still enjoy visiting it from time to time as it hangs framed in my mother's kitchen.

What do you admire in pencil drawings or designs?

I love to see added notes, comments or doodles in the margin or on the backs of pictures or manuscripts. They add a strong personal dimension not present in the original works. These elements seem that much more powerful as they are not intended for an audience but have simply been added for a personal reason, in pencil.

Your work shows a love of traditional tools and everyday objects. What do you most admire about the humble pencil?

What I love most about the pencil is how little it has changed over the last 400 years. There is something about what it can do versus how much it costs that makes it a truly democratic drawing and writing tool.

Do you draw or doodle just for pleasure?

For pleasure I mess around with watercolours, deliberately not using a pencil, trying to discover how to work with less control.

Do you ever use pencils in unusual ways?

Now that I have a Pencil Dice I sometimes use it to help me make choices.

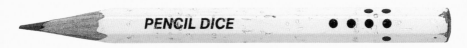

PENCIL DICE

Kale, Tomato & Lemon
one-pot spaghetti

Ingredients...
400g spaghetti or linguine
400g cherry tomatoes
The zest of 2 unwaxed lemons
100ml extra virgin olive oil
2 heaped teaspoons of sea salt
400g kale stripped from its sta[lk]
Parmesan or Pecorino cheese

Method...
Fill and boil a kettle and get all yo[ur]
ingredients and equipment together
will need a large shallow pan with

Put the pasta into the pan - you wa[nt]
to lay flat on the base of the p[an]
Chop the tomatoes in half and ad[d]
them to the pan. Grate in the ze[st]
both the lemons and add the o[il]

ANNA JONES

Cook, stylist and writer Anna Jones is the author of two books, *A Modern Way to Eat* and *A Modern Way to Cook*. She writes regular columns for *The Guardian Cook* and *The Pool*.

Where does the pencil fit into your creative process?
Often I'll write a first draft of a recipe on my computer, typing with floury fingers or sticky thumbs while in the kitchen, juggling my little boy on one knee. But when I or one of my team come to cook the recipe again – either for a shoot or for another test – I'll print it out and make mark-ups using a trusty pencil. There's nothing really like it for making changes – revising a quantity or adjusting a cooking time. I get left with piles and piles of chutney-stained A4 sheets and have to try and make sense of them before they somehow get turned into a book.

Pencils crop up in your food writing and recipes fairly often, in descriptive or comparative moments: 'pencil-thin carrots' in a roast spring roots dish, 'pencil-thick pieces' of fried tofu in your brown sugar tofu rice-paper rolls. Are pencils a standard reference in your aesthetic apparatus?
What's great about pencils is that they are pretty much a universal measurement. My books have been translated into lots of different languages, but everyone knows what I mean when I say 'pencil-thin'. I'm not sure 'pen-thin' would be quite as easy a description because it could be a biro, a fountain or a Sharpie.

Tell us about a person whose pencil drawings, designs or notebooks you admire, and why.
Last year I went to Quentin Blake's exhibition at the House of Illustration. I have long been a fan but this really cemented him in my mind as a true drawing genius. I especially loved his frayed notebooks, jam-packed with intricate characters. I saw he recently redesigned the menus for J. Sheekey, a classic pre-theatre destination restaurant in London, and the drawings look every bit as wonderful as you'd imagine.

IAN CALLUM

From the moment he laid eyes on the Jaguar XJ6 at the age of fourteen, Ian Callum knew he had found his dream job. He has worked for Ford, TWR, Aston Martin, and in 1999 he became design director of Jaguar.

Please tell us a little about your photographed pencil, the 5B Shadow Play [see page 97].
It's a WH Smith pencil. I often end up buying them at the airport before I fly, because I keep forgetting them. This particular one I bought at Heathrow. It's been used a lot, mainly on aeroplanes to sketch while I fly long-distance. The great thing about it is it's a very inexpensive item, but from it you can create the idea of anything.

The drawings you sent, at fourteen years old, to Bill Heynes, the Vice Chairman of Jaguar, were incredibly accomplished. How did you learn to draw like that?
I started drawing at the age of three, when I would instinctively draw objects around the house, such as a Hoover, and I remember drawing my mother's Kenwood mixer. One day my mother's cousin, who was a civil engineer, showed me how to draw wheels in perspective and that was the start of me drawing cars. I took a drawing of a car to show my teacher on my first day of school, having just turned five.

Tell us about one person whose drawings you admire, and why.
A chap called Frank Wootton. My grandfather gave me two of his books, *How to Draw Cars* and *How to Draw Aircraft*, when I was about six years old. He was a remarkable artist and his drawings were hugely inspiring.

Describe your perfect pencil, real or imaginary.
My perfect pencil is the Blackwing Palomino. It's perfectly balanced and has an eraser on the end which is always very useful, especially when travelling. Buying a box of these is quite a treat.

How free are you to draw from your imagination when you're coming up with designs, given that you also have to think about manufacturing, engineering and various other constraints?
Initial thoughts are not inhibited by the constraints of manufacturing or engineering. It's important to start with a clean page, without inhibition. However, very soon after that you really have to be realistic.

What can you do with a pencil that you couldn't do with a tablet or stylus?
Spontaneous line and texture. A pencil is like a language, you can use it without thinking about it. A tablet for me still requires too much concentration in the process.

How does the idea for a new car begin? Do you start with a brief, an idea for what the car might mean to someone, or a sketch?
A car starts with a brief, very quickly followed by lots of sketches. But sometimes I don't bother waiting for the brief!

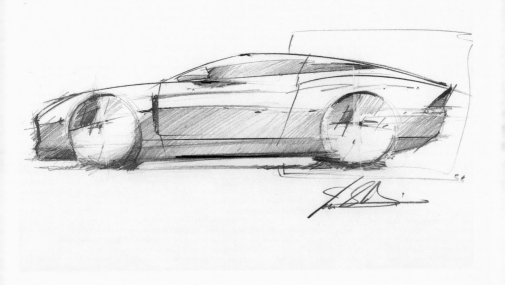

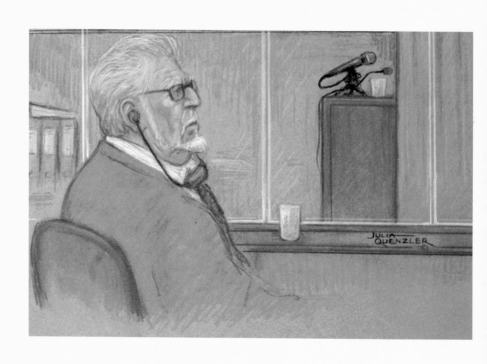

JULIA QUENZLER

Julia Quenzler has always preferred drawing from life. Prior to her work as a court artist, she had studios in California and Arizona, selling her portraits of Native Americans in Wyoming and New Mexico.

What kit do you keep at the ready?
I have my portfolio with a lightweight foam-backed drawing-board, a box with an assortment of coloured pencils and masking tape so I can tape a drawing onto the board in case it's windy, plus a couple of bulldog clips. It's all very primitive. There's been times we've had to go into a coffee shop if it's raining, in order to film the drawings.

Can you describe your beginnings as a court artist?
I was living in California where I used to see court drawings on the television and I contacted a TV station to ask if they needed a court artist. They said, 'come in and draw some of us in the newsroom, let's see what you can do'. They sent me on an assignment the next day.

And back in England, was it an easy transition to keep doing that work?
It wasn't! I initially contacted the BBC and the response was, we don't do that sort of thing in England, which was true at that time. I tried again a couple of weeks later and the person I spoke to liked the idea, and again sent me on an assignment the next day. So that was it, I was in.

Where exactly does the pencil come in when you're working in a court situation?
Naturally the pencil is paramount. Because it's a contempt of court in this country to sketch in the court room, I'll go in with only a shorthand notebook

and I'll take a few notes, but primarily I'm just looking at someone and committing them to memory. When I feel I have enough information I'll go to wherever I'm going to work. I hope to find an empty consultation room; if there's one available with a table I might work in there. Worst-case scenario, I'll draw sitting in a public area balancing my board on my lap and having to answer questions from people wanting to look.

What is the pink pencil in the photograph used for [see page 100]?
That's a colour I use very sparingly. It's only there to give a touch on the lips, the cheek, and most importantly the ears. I believe it brings a portrait to life. There's no other pencil or colour like it. It's a pink but not an insipid one. It just shows that there's blood running under the surface of the skin. It brings the drawing to life. Unfortunately CarbOthello discontinued this colour some years ago and I'm down to one full pencil and one tiny two-inch piece.

Does drawing enter into your leisure time at all?
All the time. I can be sitting at home watching television and suddenly I'll pick up a pencil and a piece of paper and I'm drawing an imaginary face. Occasionally I might do a sneaky drawing of a passenger asleep on a train. If I have time I might go along to a life-drawing workshop. It's great to be able to draw from life rather than only from memory, which of course I'm restricted to doing with the court drawings.

SIR PAUL SMITH

Sir Paul Smith is a British fashion designer whose reputation is built on men's fashion with a special focus on tailoring, or 'classics with a twist'.

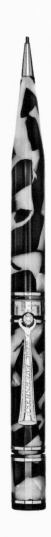

Where does the pencil fit into your creative process?
I use a pencil daily. I'm not a regular user of computers anyway, but I do think simple tools like the pencil are less formulaic, which means the results are more interesting. You make mistakes, and from mistakes you can get great ideas!

You have been incorporating pencils and pens into your designs over the last few years, from your stripy pencil-stub cufflinks and your Caran d'Ache ballpoint collaboration to boxes of actual coloured pencils. Is the basic pencil itself already an iconic design?
Absolutely! A simple wooden pencil is beautiful. Often the best design ideas are the simplest. The pencil is definitely an example of that.

Tell us about a favourite pencil-related moment.
I once found a beautiful flat red pencil which apparently was for marble- and woodworkers to use, because a flat pencil makes a wider mark.

Tell us about someone, living or dead, whose pencil drawings, designs or notebooks you particularly admire.
Well Leonardo da Vinci is an obvious one. But Salvador Dalí's pencil drawings are also amazing. For someone so heavily associated with surrealism and colour, many of his pencil drawings are the complete opposite – not what you'd expect at all.

CHRISTOPHER REID

Christopher Reid is a poet, essayist, cartoonist and writer. He won the 2009 Costa Book Award for *A Scattering*, written as a tribute to his late wife.

Where does the pencil fit into your creative process?
Generally, a poem happens like this: first thoughts as I find words and begin to shape phrases and lines, then pencilwork to catch them on paper, then the keyboard to develop and continue them. There's a different weight on each part of the process for any one poem, but that's the way it tends to go.

You are one of the few contributors to our project to send more than one pencil to represent you [see page 103]. Is it important to have a range of pencils and pencil colours to hand?
I must have about fifty or sixty pencils, all colours, in front of me now, and I can't resist buying more when I see particularly lovely specimens. No doubt there's an element of fetishism about this.

Are pencils for every day?
Oh yes, and there's a fetishistic pleasure in choosing the day's colour or colours. Like starting the day by putting on the right match of clothes.

What have pencils allowed you to do that other writing or drawing instruments might not?
I use pencils because I can't handle pens. The way I hold a writing implement – thumb tucked under index finger – makes for a very cramped and laboured movement of the hand. Nibs don't like that, and pencils are the only things that allow me any chance of lightness or fluency. I must have been taught badly in early childhood, because I've never been able to correct my grip.

Where can we see or read the fruits of your pencil work?
It's all hidden away in early drafts of poems that nobody sees except me.

Tell us about someone whose pencil work – drawings, designs, notebooks, poems, whatever – you admire.
I love and envy the handwriting of certain artists. Ben Nicholson comes immediately to mind: every letter elegantly formed and joined to the next, but with the total effect of having been almost negligently dashed off. German artists, I've noticed from pencilled signatures under prints, often have beautiful handwriting.

Has a pencil ever led you astray – into theft, rudeness, graffiti, inelegance, unmetricality or worse?
That's a nice list of crimes and misdemeanours. If inelegance or unmetricality occurs it can only be blamed on me, and certainly not on my innocent pencil. To the rest, I plead Not Guilty.

SOPHIE CONRAN

Sophie Conran is an English interior designer, cook and author, whose glass- and tableware range for Portmeirion received Elle Decoration and House Beautiful awards.

Where does the pencil fit into your creative process?
I always like to have a pencil to hand. I love nothing more than getting a big pack of coloured pencils and grading them by colour. I like to be very organized and carry a little pencilcase around with me should I ever need to jot a thought down – particularly handy for drawing on paper tablecloths to illustrate a point or play a game.

What have you created with the pencil in the photograph [see page 104]?
It's very much my doodle pencil. I use it to jot down my thoughts, which could be anything from shapes or designs to notes and numbers, and all sorts of weird and wonderful ideas that fill the margins of my notepad.

Are your pencils for everyday use or for special occasions?
I carry both in the pencilcase I keep in my handbag; however, this particular pencil came as part of a much-treasured Christmas present from my little sister, so I guess you could say it was more for special occasions.

It might be an understatement to say you are keen on colour. Does this lead you to favour coloured pencils?
It absolutely does. I really do love colour and I like to introduce it in all aspects of my life – a cheery pink or yellow can never fail to raise a smile and cheer you up!

You are not only a food writer and interior designer but also a food and product stylist. How does the venerable, lo-fi technology of the pencil fit with your aesthetic approach to design?
When I design I always endeavour to create something beautiful yet practical and that, in essence, is the pencil itself. There is something very honest about the humble pencil, which I love. If you look at my collection with Portmeirion, I design it with a feel that all the pieces are hand-thrown, and that stems from these original pencil drawings of ideas and samples that I have picked up from my travels. My design ideas then go off to our master potter who hand-throws the original pieces and thus new products are born that we hope will be loved in homes all around the world.

Tell us about a favourite pencil-related moment.
It was definitely when I received an exquisite box of 300 coloured pencils from my mum and dad for Christmas when I was about twelve. To pull back the packaging and be greeted by joyful rainbow tones and endless possibility was just delightful.

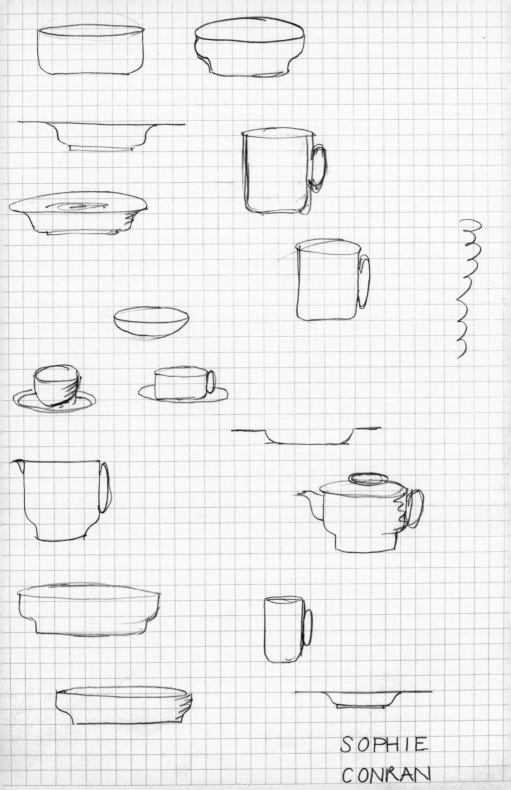

SOPHIE
CONRAN

About The Secret Life of the Pencil

The Secret Life of the Pencil project came about after co-founders Alex Hammond and Mike Tinney had a casual discussion about the changing creative scenes in which they both worked. They found they shared a concern that, despite the staggering technological advances in their respective fields of industrial design and photography, this could sometimes be to the detriment of creativity in its purest form. Would the touchscreen generation ever feel the pleasure of a freshly sharpened pencil or the frustration of a shattered lead?

In response, they decided to celebrate the often-overlooked pencil by photographing examples belonging to creatives at the highest level of their professions. By making pencil portraits, they sought to capture these tools in all their simplistic beauty.

The project subsequently generated an exhibition, which continues to tour internationally, and supports the charity Children in Crisis through the sale and auction of limited-edition prints.

About the authors

Alex Hammond is a designer specializing in product and packaging. He also applies his art and engineering background to the wider design field, producing branding, photography and CG visualizations.

Mike Tinney is a British-born still life and documentary photographer. His clients include Casio, Dior, Gucci, Haagen Dazs, Jameson, Nike and Ted Baker.

Acknowledgements

Thanks to our families and friends for supporting us throughout this project.

Special thanks to: all pencil contributors and their associates; Adam Spink and Calum Crease; Alan Aboud; Ben Cox; Ben Monk; Chris Bedson; Claire Lawrence; Coco Fennel; Dave Pescod; Ed Reeve; Eddy Blake; Giorgia Parodi Brown; James Lowther; James Smales; Joe Spikes, Koy Thomson and all at Children in Crisis; Lawrie Hammond; Leo Leigh; Lisa Comerford; Liza Ryan Day; Lucy Adams; Mark Champkins; Mark Pattenden; Nathan Gallagher; the Paul Smith team; Peter Mann; Simon Turner, Kate O'Neill, Steve Macleod and Martyn Gosling at Metro; Sophie Lewis and Sarah Courtauld; Sutveer Kaur; Tom Skipp; Zoe Tomlinson; and of course all at Laurence King, especially Felicity Maunder, John Parton and Marc Valli. Thank you for believing in our project.

Image credits

Published in 2017 by Laurence King Publishing
361–373 City Road
London EC1V 1LR
United Kingdom
Tel: +44 20 7841 6900
Fax: 44 20 7841 6910
email: enquiries@laurenceking.com
www.laurenceking.com

A catalogue record for this book is available
from the British Library.
ISBN: 978-1-78627-083-2

Book design by Studio AS-CC
Interviews by Sarah Courtauld and Sophie Lewis

Printed in China